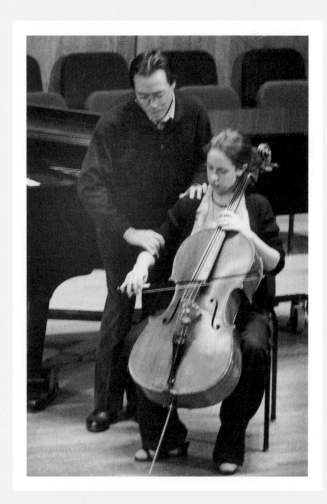

teaching
MUSICIANS

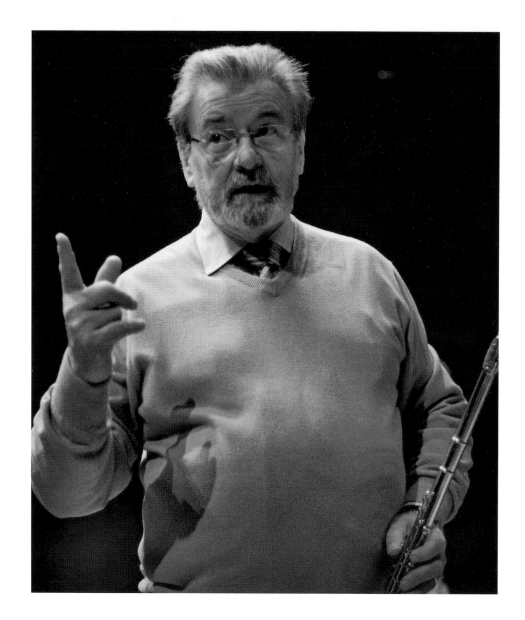

Sir James Galway

teaching
MUSICIANS

A Photographer's View

DIANE ASSÉO GRILICHES

BUNKER HILL PUBLISHING

www.bunkerhillpublishing.com

First published in 2008
by Bunker Hill Publishing Inc.
285 River Road, Piermont
New Hampshire 03779, USA

10 9 8 7 6 5 4 3 2 1

Library of Congress Control Number: 2007926766

ISBN 10: 1-59373-060-8
ISBN 13: 9781593730604

Designed by Louise Millar

Printed in China by Jade Productions Ltd

This book honors my own great music teachers

Joseph Leonard
Felix Ganz
and
Judith Gordon

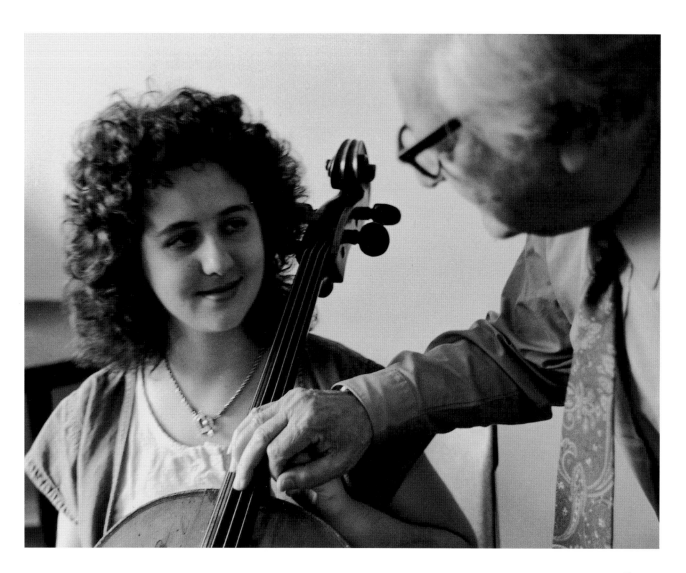

George Neikrug

Contents

Acknowledgements

It was while I was doing some photographic work at the New England Conservatory of Music that I made the first image that was to become a part of this book. That was of the cellist, Colin Carr, whom I spied under the bow arm of his student, Dorothea Wolff, during a lesson. I was given the privilege of approaching a number of teachers in this great institution, and sitting in on fascinating sessions of communication between teachers and students while trying to capture moments that would stay permanently fixed visually, while the sounds continued ephemerally out into space. It was also at NEC that Hankus Netsky, head of the Jazz Department, made suggestions to me about whom to approach for further images.

At the Tanglewood Music Center I made several images, and I am indebted to Ellen Highstein, TMC Director, for her communications to those great teachers at the Boston Symphony Orchestra's summer teaching institute, allowing me to photograph them with their students. And during the regular year it was BSO violinist, Sheila Feikovsky, who made pathways for me to other symphony players.

At the Juilliard School it was Dorothy de Lay (whom violist Raphael Hillyer suggested I approach) who was so open to my twice sitting in on her lessons, and on a lesson given by her former student, Itzhak Perlman.

At the Longy School of Music in Cambridge, Massachusetts, I am indebted to former President, Kwang-Wu Kim, at Harvard University to the great scholar Professor Christoph Wolff, and at the Chicago College of Performing Arts to my friend, the Dean, James Gandre, all for their writing in support of this project.

At Boston University School of Arts I am grateful for the time given me by the great singer and teacher, Phyllis Curtin, who then sent me to that amazing cello teacher, George Neikrug, and I was honored by the great violinist, teacher, and humanist Roman Totenberg, for twice welcoming me into his studio (with freely flying canaries) for my photo-making.

It was my nephew, Steven Copes, concertmaster of the St. Paul Chamber Orchestra, who opened the delightful path to Bobby McFerrin, teaching at the University of Minnesota. Chitra Raghavan Staley made the connections for me to Ravi Shankar in Encinitas, California, so that he welcomed me into his home for more time than he usually gives most visitors (according to his charming wife, Sukanya). It was Martha Faulhaber who encouraged me to come to Chicago where Betty Xiang, erhu player and teacher, and her husband Yang Wei, pipa player and teacher, were working, so that I might make photographs of them.

To my neighbor, friend, writer and editor Gail Pool, I am again indebted for all the time she took to make suggestions on my proposal writing, to Patti Obenour for her most helpful suggestions of the same, and to Peter Rose, Diane Becker, and Dorothy Magadieu for helpful editing.

I am so grateful to the N+1 Photography Group for their continuing support and helpful critiques of my work. It has been motivating and properly humbling all these years.

Thanks to Tom Lee at Harvard University's Learning from Performers program for giving me access to their visiting musician/teachers.

I am so grateful for the smarts and skills of both Rob Chirico, the editor, and Louise Millar the designer. They made very good what certainly needed making better.

To Ib and Carole Bellew of the Bunker Hill Publishing I am indebted for the wisdom and heart they have to see this project as worthy of their publishing endeavors. It has been such a pleasure to work with you.

Finally, I am so grateful to all the fine teaching musicians and their students who welcomed me into their inner sanctums to capture and run away with their images. I hope they will be pleased with the results of these felicitous encounters.

Richard Ortner

Foreword

In creating the images that make up this extraordinary book, the art/documentary photographer Diane Asséo Griliches gives us entrée to private places and privileged moments – the places and moments that precede what we hear when we listen to great music. She captures the sacred space of a music lesson where students and teachers (some famous, familiar, iconic; others less known) put aside ordinary things, clear their minds, and open themselves to an exploration that is not for the timid or the immature. These photos allow us to eavesdrop on students at moments of enormous vulnerability, and on their teachers at moments of tremendous responsibility. With this photographer as guide, we watch as young people are asked to struggle, to strive, to embrace failure and imperfection as fully as joy and success, or perhaps to confront that most adult of demons – ambiguity.

Along with mathematics, music is the particular attribute of intelligence that transcends spoken language and connects us directly to the ineffable. (The new neuroscience confirms the place of these non-verbal languages as "hard wired" in humankind.) Whether our music of choice is traditional or tribal or jazz or rock or the stylized sophistication of Western or South Asian classical musics, we sense things our ancestors knew – things that all of the centuries intervening, and all of our technology, have not changed: we are born, we age, we die – and we don't know why. The Greeks understood that music is one key pathway in the human search for meaning; thus they knew that the teaching of music has crucial importance in our struggle to convey the strange wonder of the human condition. Teaching young ones is surely the work of the angels, and we bless those teachers for their devotion; teaching serious young artists is the realm of sages. These we revere as spirit guides, and some of our greatest are found, at their work, in these pages.

For those of us who have tried it, teaching music is alchemy. Its best practitioners are the mages of our time. Sometimes the work is simple chemistry, as "third finger here," or "softer!" But more often, more importantly and more mysteriously, master teachers act as gatekeepers whose secret spells are passed down verbally from generation to generation, as guild secrets are. They are not shared with everyone equally – only demonstrated adepts receive the most powerful charms in their mentors' arsenals. How fortunate, then, that we have a spirit guide of another kind, equipped with lens and film, to help us experience and understand what happens when a Seiji Ozawa peers in at a young woman trying to master a key solo passage for English horn, or cellist Colin Carr reaches inside for the image that will transform his student's playing, or ... well, the images themselves will tell you the story.

The transmittal of that divine spark – that Old Testament moment we know from the Sistine ceiling – is indeed "creation." A new state of mind is being created. It is instantaneous, shocking, transformational, and permanent. Diane's photos of these fugitive moments accomplish the miracle of allowing us repeated visits, extended contemplation, and finally the mapping of these stories onto our own personal experience of transformative events. The photos stand as witness to that instant of change: for these fortunate young people, it is the gift of a framework for continual questioning that remains with them for life. (It is, after all, the questions that greatly gifted teachers impart, not the answers.) For us, it is the gift of participation: her eye for action – as well as for repose, and for capturing the very moment when change is created – puts us there.

For those of us privileged to be in the presence of great teaching, the experience is deeply personal and utterly memorable. I think always of violinist Louis Krasner, who thrilled and perplexed his young disciples by saying, with sweetly wrinkled brow, "to play this movement you must sprout wings and live in heaven," or "you

know, that phrase is sunnier in the third position" ... or of Phyllis Curtin, fearlessly evoking Beauty (without question, one could hear the capital "B"), challenging a young singer to call forth that Beauty, to create a numinous presence in the room ... or of Leon Fleisher, eyes closed, head tilted upward, describing the pulse in a Brahms quintet movement as the stroke of an oar in water, with its quick surge of energy and measured release and decay – indelible images that challenge and forever change a student's approach to the struggle. The result? – new awareness permeates the music-making of these young artists, and they in turn enrich our experience as listeners.

Through the gift of this photographer's presence, we too are present at the moment of change. Can this moment truly be stopped? Can it be held? Let me invite you to turn the page.

<div align="right">

Richard Ortner
President, The Boston Conservatory

</div>

(Between 1974 and 1996, Mr. Ortner was Assistant Administrator,
then Administrator, of the Tanglewood Music Center, the Boston Symphony
Orchestra's renowned summer academy for advanced study in music.)

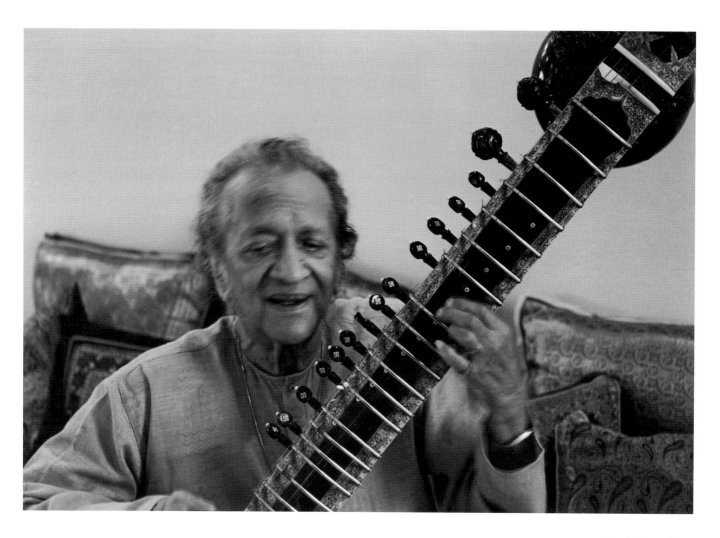

Ravi Shankar

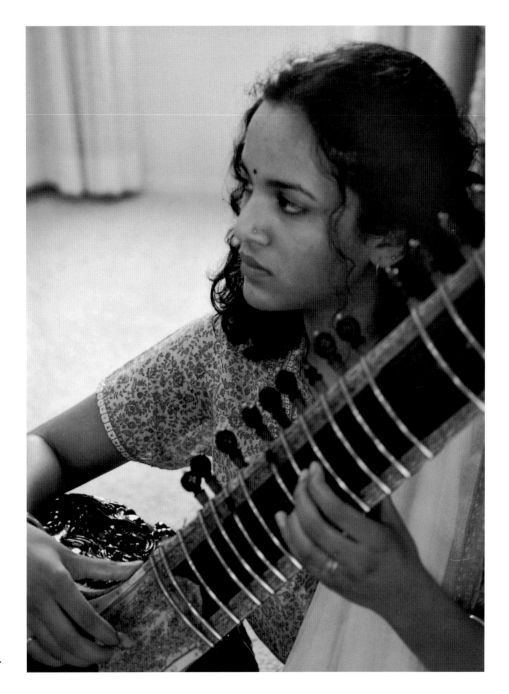

Anoushka Shankar

Preface

Thomas Wolfe spoke of "the transforming passion with which a great teacher projects his ideas." Nowhere is this so evident as when one observes the musician/teacher working with a student.

As a musician myself, I have both experienced and observed the many distinctive ways in which music teachers approach their students, and as a photographer I have worked to create a book that captures visually what happens in these animated sessions. Black-and-white photography is able to bring out the dramatic elements of an image, while illuminating the instruments' textures, an abstract form of photography, without color while colorful in expression.

As for my own musical education, it was an inauspicious beginning, with a frightening piano teacher who might very well have quashed an 8-year-old's enthusiasm. A second teacher was tried with no luck. I wanted a teacher but not the packages they came in. But soon after, still at age 8, I acquired a third teacher, Joseph Leonard, who became, over the next ten years, my father confessor, mentor, and the person who conveyed to me what music is all about. By the time I reached my early teens there was much time spent over coffee and cake before the lesson, talking about life and music. Only many years later did I really understand how important he had been to me.

Later, in college, there was another great teacher, Felix Ganz, at Chicago Musical College (to become the Chicago College of Performing Arts), with whom I continued exploring and finding joy in music making. These teachers believed in me, believed I could accomplish what they expected of me and what I wanted for myself as an amateur pianist of chamber music, and for that I am profoundly grateful. My studies continue with another great teacher, Judith Gordon.

This book is a tribute to my own teachers who gave a profound artistic dimension to my life, as well as to all the great teacher/musicians in the world, and especially to those represented herein.

In making my choices of subjects I looked for a diversity of instruments and areas of music: classical, jazz, and ethnic, and I chose the particular musicians on the basis of their reputations as great teachers and musicians. While most of these musicians have had world-wide performing careers, many have come to emphasize teaching at a certain point in their careers, feeling a responsibility to pass on what they know.

The public has seen many of these artists in concert, but I was privileged to have had access to them as they were working with their students, this "other life" of the musicians, in situations the public rarely sees, except in the format of a master class. That many would like a chance to see what this teaching looks like was evident during a heavily attended exhibition of these photographs at the Boston Public Library's Great Hall in 2003, when hundreds of viewers enthusiastically responded to them. Unfortunately, a few of the musicians I photographed are no longer living, but these wonderful moments are captured visually for posterity.

Both teachers and students welcomed my prearranged visits and seemed to become relatively unaware of my presence after the first few minutes. I attribute this to the fact that musicians are performers before audiences, accustomed to being observed, and for the most part enjoying it. I also worked with a small, almost noiseless Leica range-finder camera, using only ambient light in all situations.

But the photographer is entering into often intimate experiences. The students are sensitive, vulnerable, reaching for confidence and achievement, and the teachers are trying to pass on techniques, styles and traditions, and to give the students a sense of self through their art. One may observe in the teachers sweetness and encouragement, humor, quiet contemplation, critical commentary, generous guidance, and excited demonstration. Body language and facial

expressions can convey much in attitude and approach, and through these intense images one can experience the importance of the making of a musician. In some instances the quietest part of the lesson may prove the most interesting visually. Says the great violinist/teacher Roman Totenberg: "The open face of a student who discovers something is quite unforgettable". At other times a lesson may get athletic, requiring a faster shutter speed.

Of course teachers attempt to convey musical ideas verbally as well. Cellist Joel Krosnick doles out rich meals of historical and musical insights. Many teachers communicated with stirring and imaginative words, and I tried to catch these gems in flight while I was photographing, and put them down on paper to accompany the images. Had Leonard Bernstein been around when I was working (they say he was preaching as well as teaching) I might have been able to share his political, philosophical, and personal beliefs with the reader, but, alas ...

For me there were surprises all along the way: how the Finnish conductor and teacher of so many fine conductors, Jorma Panula, was able to convey so much to his students while hardly saying a word; how the magetism, humor, and humanity of Bobby McFerrin got his students to loosen up and become creative on the spot; how Ravi Shankar, with his singular approach, is able to be both father and strict teacher to his daughter, now a star performer herself.

The whole notion that teachers are passing on to their students a priceless tradition (learned from their own teachers) also inspired me to undertake this project. The field of musical pedagogy differs from teaching in the other arts. Its long uninterrupted tradition is so well known that we are usually told with whom a particular musician studied when we read a concert program. It emphasizes the importance of studying with certain great teachers for those teachers' wealth of knowledge. The highly emotional experience of musical pedagogy is bound to links with the past, the legacy of a culture needing to be passed on, and this is true in jazz, classical, and ethnic music.

Henry Adams, the historian, journalist, and novelist, said that a teacher affects eternity. With music one can see a pedagogical genealogy, great teachers who taught great musicians who became great teachers who taught great musicians: Haydn and Salieri taught Beethoven who taught Czerny who taught Liszt. And Beethoven's pupil, Czerny, taught Leschetizky who taught Vengerova who taught Leonard Bernstein. And Bernstein studied for years with Helen Coates who had studied with Gebhard who had studied with Leschetizky who studied with Czerny who studied with Beethoven who studied with Haydn. Thus Leonard Bernstein's great great great pedagogical grandfather was Haydn ... his teacher's teacher's teacher's teacher! Victor Borge was also a pupil of a pupil of Liszt who was a pupil of a pupil of Busoni. Zemlinsky taught Schoenberg who taught Berg, Webern, and Dave Brubeck. And in many cases it was the student who made the teacher famous.

And so I pass on to the reader/viewer the fruits of my happy labors with these great pedagogues and their talented students. Ansel Adams said that photography is full of the expression of what one feels about what's being photographed. I was always moved by how these teachers were sharing their gifts, and taking such good care of talent, knowing they were dealing with vulnerable human lives, and I hope my photographs communicate that.

Having had the great privilege of sitting in (so to speak) on so many classes while photographing amounted to hours of free lessons in musicianship, without having to go home and practice!

* * *

A note on the photography: In all cases I used my Leica CLs with Ilford 400 b/w film, with normal, wide angle, and 90mm lenses. I never used flash, and the camera was always hand-held, allowing me to move about freely. Photographs were made at the New England Conservatory of Music classrooms and in NEC's Jordan

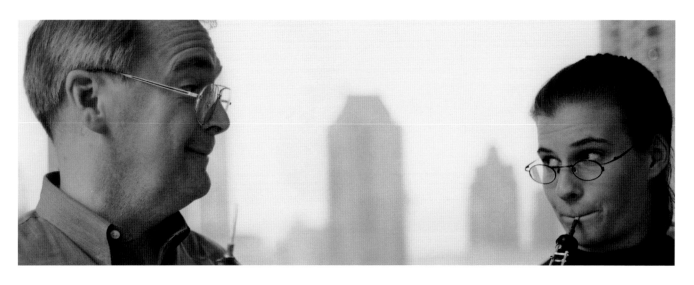

Joseph
Robinson

Hall, the Manhattan School of Music, the Berklee College of Music in Boston, the Juilliard School in New York, the Ali Akbar College in California, Boston University School of Fine Arts, Wellfleet Public Library, Harvard University's Sanders Theatre, Harvard University's Music Department classroom, the University of Minnesota, the Longy School of Music in Cambridge, the East Harlem Public School, the Community Music Center of Boston, the Lincoln School in Brookline, the Boston Conservatory of Music, Boston Symphony's Tanglewood Music Center, and the BSO's Higginson Hall. I made a number of photographs in the private homes and studios of the teachers as well (Totenberg, Sherman, Shankar, Robinson, Hobson Pilot, Henson-Conant, and Blake).

Toscanini called photographers "assassins"! It is true that we stalk our prey, but in the best sense, and with a critical eye, we immortalize precious moments, and then share them with others. I believe Toscanini would have approved.

Diane Asséo Griliches

"Do you feel the difference? You're not fighting to get it out. And there's got to be intelligence going on, not just feeling!"

<div align="right">DANILO PEREZ</div>

Danilo Perez

The Teachers

Pablo Ablanedo
Emmanuel Ax
Frank Battisti
Ran Blake
Liz Borg
Colin Carr
Swapan Chaudhuri
Hal Crook
Phyllis Curtin
Richard Davis
Dorothy DeLay
Dominique Eade
Everett Firth
Joe Galeota
Felix Galimir
Sir James Galway
Bernard Greenhouse
Roberta Guaspari
Matt Haimovitz
Jimmy Heath
Deborah Henson-Conant
Ann Hobson Pilot
Lorin Hollander
Joel Krosnick
David Leisner
Yo-Yo Ma
Joseph Maneri
Cecil McBee
Bobby McFerrin

Ann Miklich
John Moriarty
Bob Moses
George Neikrug
Hankus Netsky
Seiji Ozawa
Jorma Panula
Danilo Perez
Yitzhak Perlman
Menachem Pressler
Ken Radnofsky
Joseph Robinson
Paula Robison
Ravi Shankar
Robert Sheena
Russell Sherman
Johanna Hill Simpson
Joel Smirnoff
James Sommerville
Roman Totenberg
Charles Villarrubia
Roger Voisin
Yehudi Wyner
Betty Xiang
Owen Young
Benjamin Zander
Aideen Zeitlin
Jacques Zoon

"The loss of my vision meant no more reading of music, after a lifetime playing my flute, cello, and viola da gamba. Pablo helped me remain a creative player by guiding me into composition and improvisation at the piano."

MILENA ALLEN RIES

Pablo Esteban Ablanedo is a composer, pianist, and teacher. A native of Buenos Aires, Argentina, He has resided in the U.S. since 1993 when he began his studies at the Berklee College of Music in Boston, working with, among others, the legendary teacher, Herb Pomeroy, who had a great influence on him. Ablanedo received the John Dankworth Award in Jazz Composition from Berklee. He now spends a significant part of his musical life teaching a large number of young and adult students, following the premises of the C.A.P.T.O. training created by the Argentinean pianist Susan Bonora. Parallel to his teaching, he formed the Pablo Ablanedo Octet with which he has recorded two albums: *From Down There* (2001) and *Alegria* (2003) on the Barcelona-based Fresh Sound New Talent record label. On the same label, in 2004, he produced and contributed two tracks on the double album *The Sound of New York Jazz Underground*.

"… and as you are playing you need to listen always to what your partner is playing."

<div align="right">EMANUEL AX</div>

Pianist Emanuel Ax was born in Lvov, Poland in 1949 to parents who were Nazi concentration camp survivors. He began studying piano at age 6 in Warsaw. The family moved Winnipeg, Canada two years later, where he continued to study music. In 1961 the family moved to New York City where he studied at the Pre-College Division of the Juilliard School under Mieczylaw Munz, and graduated from Columbia University.

He first captured public attention in 1974 when, aged 25, he won the first Arthur Rubinstein International Piano Competition in Tel Aviv, Israel.

Acclaimed for his poetic lyricism and brilliant technique, he is one of today's best known and most highly regarded musicians. He performs internationally and many of his recordings have won top honors, and he is much in demand.

He is a particular supporter of 20th century composers. He has given a number of world premieres of new works, and is also devoted to chamber music, which he performs and records widely.

Mr. Ax gives master classes, and in the summer of 2000 he was teaching at the Tanglewood Music Center where this photograph was made.

"Look, the pureness of sound that should be here is like a child's love, like a child's smile, tender, not mature. But it's powerful. It lights up the whole place. Just that countenance is what you should hear here."

FRANK BATTISTI

One of Boston's most distinguished and beloved musicians, Frank Battisti has been for years the conductor of the New England Conservatory Wind Ensemble, one of the premiere ensembles of its kind in the U.S.

He has appeared often as guest conductor with many wind ensembles and as guest clinician and teacher throughout the world. He is considered one of the foremost authorities in the world on wind music literature. Among the many awards he received was the Louis and Adrienne Krasner Excellence in Teaching Award from the New England Conservatory of Music.

One of his great accomplishments has been to enlarge the repertory for wind ensemble by convincing leading composers to write new works and to arrange commissions to pay for them.

He is involved now, in retirement, in developing a corps of "music missionaries" to go into the public schools in order to foster an involvement and love of music and to explore new ways of preparing young musicians to teach music.

"Everything must be learned by ear. Music is an aural art. If you want to use eyes, dig Picasso."

<div align="right">RAN BLAKE</div>

Ran Blake is an innovative pianist/composer/teacher, with thirty albums to his credit. When Gunther Schuller became president of the New England Conservatory of Music, Blake helped forge a style known as "Third Stream" there (but now called Contemporary Improvisation), a mixture of jazz, classical, gospel, and sounds from around the world.

But ask him about his music, and he'd rather talk about being a teacher. However, his approach is very un-academic. He eschews musical notation, and is working on a book called *The Primacy of the Ear*. He wants his students to concentrate on listening, and one course is called "Earobics."

Blake won a MacArthur Genius Grant some years ago and has recently (2006) released his first solo disc in twenty years, *All That is Tied*, and its reception has been "nothing short of euphoric."

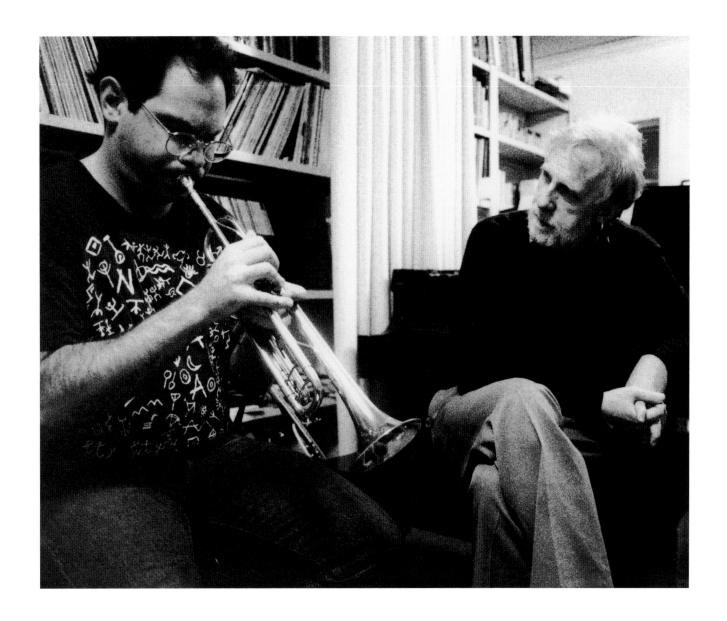

"When you relate to all the other people on stage, you give each other energy, and the production comes alive!"

<div align="right">

LIZ BORG

</div>

Elisabeth Borg, a stage and music director, received her M.M. from the Longy School of Music under Donna Roll, studying voice, and her B.A. from Smith College. She studied at the National Theater Institute/Eugene O'Neill Theater Center in Connecticut and at Gotham City Improv in New York City.

Liz has performed as alto soloist with the New Bedford, Quincy and Brockton Symphony Orchestras, the Ocean State Chamber Orchestra, and Neponsett and Scituate Choral Societies. She has toured the Middle East, Europe, and Africa as a soloist with the New England Youth Ensemble, and she originated the role of Catherine in Wolcott and Anderson's premiere opera, *Walker*, at the Boston Athenaeum, directed by Donna Roll.

Ms. Borg has taught at the Great Woods Educational Forum, Nashua Community Music School, Shakespeare & Company, Foothills Theatre, the Riverside Theaterworks, and the Longy School of Music. She is the former Deputy Director of Young Audiences of Massachusetts, whose mission is to initiate life-long involvement in the arts by making them integral to every child's education."

"The ability to listen to the voice within, to be swept along by its strength and beauty, that is a driving force greater than any teacher; for what we discover for ourselves is so much more exciting than that which is pointed out to us."

COLIN CARR

Cellist Colin Carr has appeared throughout the world as soloist, chamber music musician, recording artist, and teacher. As a member of the Golub-Kaplan-Carr Trio he has recorded and toured extensively, and recently formed the new group Sequenza. He is also the winner of many prestigious international awards.

He has received enormous recognition for his "reflective, quietly intense playing and especially his command of phrase and line … his is music-making of majestic poetry." (*The Times*, London). Strad magazine called his playing "a perfectly balanced demonstration of lyrical beauty and technical virtuosity."

Carr first played cello at age 5; three years later he went to the Yehudi Menuhin School where he studied with the great French cellist, Maurice Gendron, who was not used to dealing with children and terrified this 10-year old. He later studied with William Pleeth.

He was made professor at the Royal Academy of Music in London 1998, having been on the faculty of the New England Conservatory of Music for sixteen years. In 1998, St. John's College, Oxford, created the post of "Musician in Residence" for him, and in 2002 he became professor at Stony Brook State University of New York.

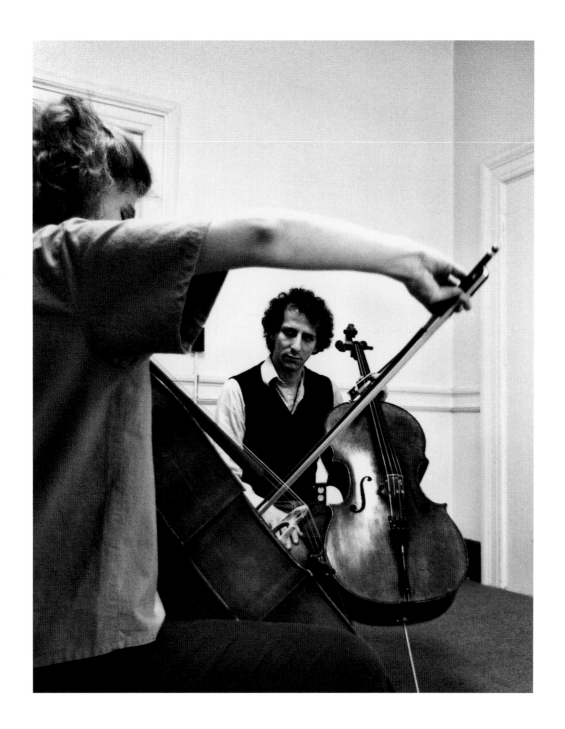

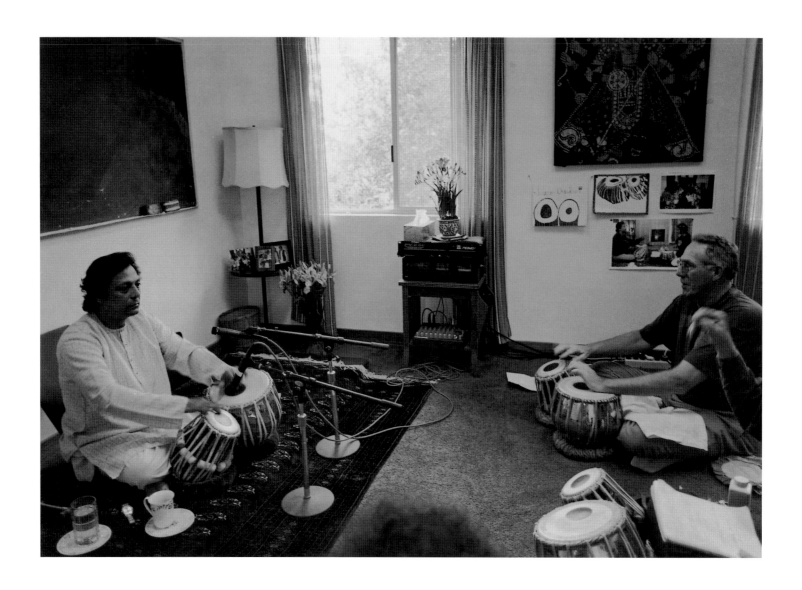

"Not a single missed beat nor a misplaced stroke will elude his vigilant ear. Though always gentle, he is exacting. In every lesson, Swapanji expects us to stretch our capabilities."

<div align="right">a student</div>

Swapan Chaudhuri is one of the world's greatest classical tabla players. A Bengali, he grew up in Calcutta in a family of doctors. His father studied flute and vocal music, and the house was "filled with mother-singing," The young boy began learning tabla at age 5 and now bases his style on his late guru, Pandit Snatosh Krishna Biswas. This music is passed on only via the guru-disciple relationship.

His family lived in the same block as the great musical family of Ali Akbar Khan, son of Allauddin Khan, the most influential force in North Indian classical music in this century, and who had also trained Ravi Shankar. Although the entire large extended family disapproved of music as a career, in time his father, a strict disciplinarian, made him practice tabla.

When Chaudhuri was 10, Ali Akbar Khan invited him to his College in Calcutta, but Chaudhuri decided to go on and do his college work in economics. However, at age 24 he was again invited to play for Khan, who then asked him to come to America to teach at his Ali Akbar Khan College in California and to perform with him.

He teaches there now, as well as at the California Institute of the Arts. He divides his time between teaching and touring world-wide, giving an average of 200 concerts a year, as soloist and accompanist for every major performer in Hindustani music, including Ali Akbar Khan and Ravi Shankar. "Tabla is limitless. I never want to stop." He teaches one of the oldest and most complex musical systems in the world and expects his students to stretch their capabilities in every lesson.

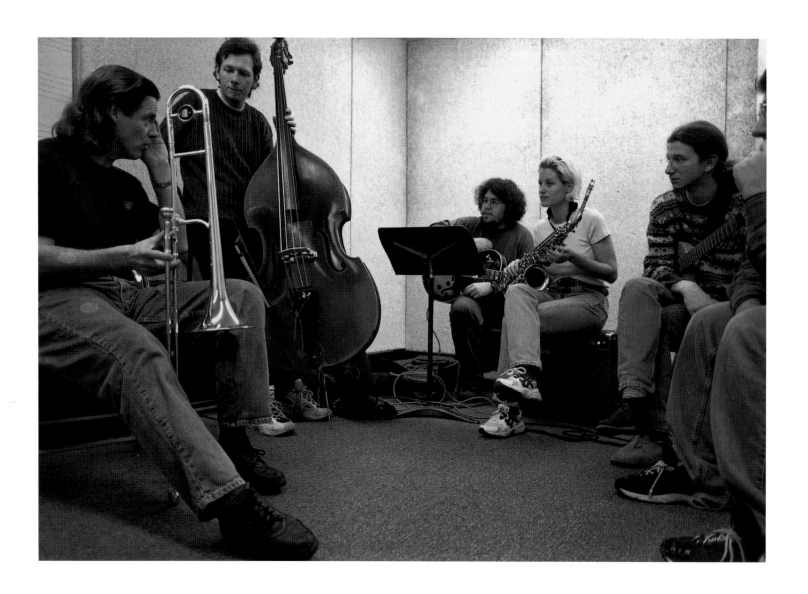

"You've got to learn to listen first and play second. Control is the important thing. Later on you can abandon yourself. Embrace your weaknesses and work on them."

<div align="right">HAL CROOK</div>

"This guy's a genius. He's the father of us all."

<div align="right">a student</div>

'Yeah, they're my illegitimate children!"

<div align="right">HAL CROOK</div>

Hal Crook is an internationally acclaimed jazz trombonist, composer, arranger, recording artist, educator, clinician and author, currently teaching at the Berklee College of Music.

He records for RAM records (Italy) and tours worldwide. He is the author of several textbooks and is the director and proprietor of jazz schools in Rhode Island and California. He presents jazz clinics and seminars world-wide.

His book, *How to Improvise*, incorporates studies in discipline, technique, creativity and musical intuition. He shares ideas, materials and provides and organied approach to practicing.

"Her teaching ... who she is, and everything about her gave me permission to become the artist I am, to be free to express with my mind and soul what I feel about music."

DOMINIQUE LABELLE, former student

Soprano Phyllis Curtin was born in Clarksburg, West Virginia, and graduated from Wellesley College with a degree in political science. However, she subsequently dedicated her life to a career as a concert and opera singer, with leading roles in opera houses in the U.S. and abroad. She has been a frequent soloist with the leading orchestras of the world, and premiered many works of twentieth-century American composers.

She became artist-in-residence at the Boston Symphony's Tanglewood Music Center in 1964 and continues in that capacity as teacher. Teaching took her to the Yale School of Music, and she has been at Boston University since 1983 as Director of the Opera Institute.

Master classes have taken her to many institutions in the U.S., Canada, as well as to the conservatories of Beijing, Moscow, and Tbilsi. She held a presidential appointment to the National Council for the Arts, among many other honorary appointments. Ms. Curtin won the 1997-1998 Luise Vosgerchian Teaching Award from Harvard and Radcliffe. She is one of America's premiere teachers of singing and vocal performance.

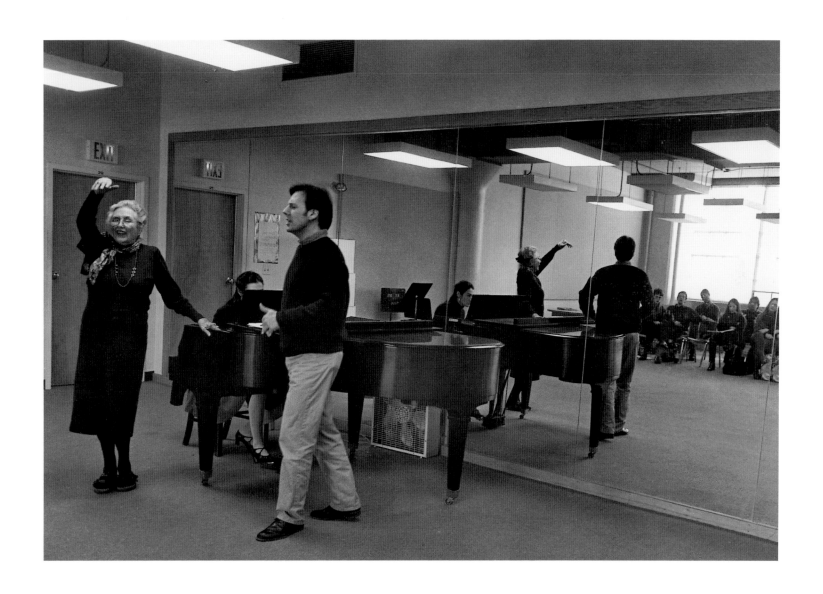

"What are you really trying to say here with the music? Make sure that every measure you write is backed by your strong conviction of the dramatic and emotional needs of the scene."

<div align="right">RICHARD DAVIS</div>

Richard Davis is Professor of Film Scoring at the Berklee College of Music. He is an educator, composer, orchestrator, record producer, and author. In addition to film scoring classes, he also teaches counterpoint and conducting.

He has worn many hats in the music business. He began his professional career as a bluegrass banjo player, and went on to focus on jazz guitar, performing in jazz festivals.

Film credits include orchestrations for feature films and TV shows. Personal appearances as musical director or sideman include Phylicia Rashad, Betty Buckley, Lulu, Gloria Loring, John Denver, Illinois Jacquet, and Meg Christian.

In the past few years he became involved in two new areas: East Indian music and songwriting, and he produced several CDs based on Hindu melodies and ragas, and a full-length CD by New England singer-songwriter Enid Ames.

Richard recently published the *Complete Guide to Film Scoring: The Art and Business of Music for Movies & Television.*

TCR 01:00:57:23

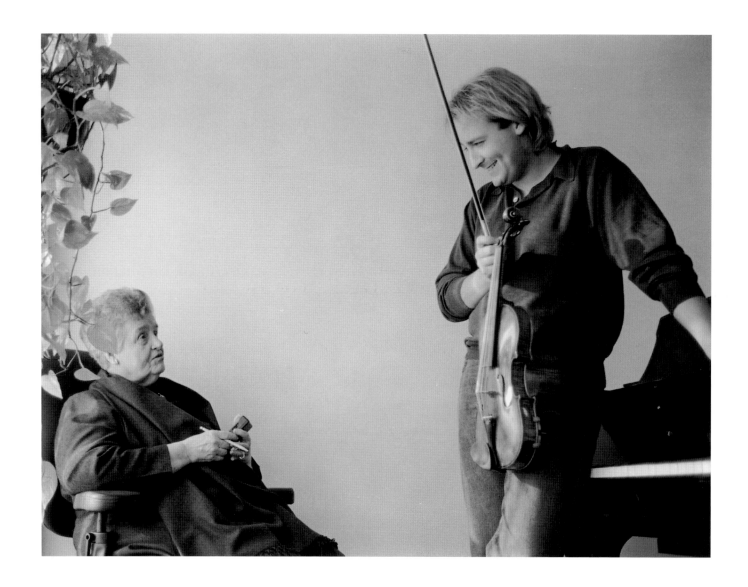

"I think the greatest thing about Dorothy DeLay is that she has the ability to look at a young student and pretty much size up their character, their personality, and how in a short period of time what's the best door to use to get them in. And that's her method – the fact that there is really no method."

<div align="right">NADJA SALERNO-SONNENBERG</div>

Called the world's most revered violin pedagogue, since 1947 Dorothy DeLay has taught two generations of great violinists, among them Midori, Itzhak Perlman, Gil Shaham, Sarah Chang, Nadja Salerno-Sonnenberg, Shlomo Mintz, and Nigel Kennedy. Among her pupils are also founders of some of the world's great chamber groups: the Juilliard, the Tokyo, the Cleveland, and the Vermeer. Others became concertmasters and conductors.

She herself was a student of Ivan Galamian and others at the Juilliard School. The faculty there includes fourteen of her former students. She was known for giving homey advice and asking her students for their opinions, and for her demanding five-hour practice regimen.

She was married to Edward Newhouse, novelist and short story writer for *The New Yorker*, and he survives her. She died in March of 2002. Emphasized in a book about Miss DeLay, *Teaching Genius*, by Barbara Lourie Sand, was the fact that she had no secrets; she saw traits worth developing in her pupils, expected a lot, asked questions, and helped them to be themselves.

"If I can spark a sense of discovery in my students, if they can forget what they think they should know and become caught up in what it is they are actually learning, then I know I have taught them something that will serve them beyond the classroom, and perhaps beyond music."

DOMINIQUE EADE

"Being in the same room with Dominique was in itself inspirational. It will always be with me."

LUCIANA SOUZA, former student

Dominique Eade is a vocal improviser who "applies scat with greater variety than most singers." Her singing has been called "risky" and "haunting," while always respecting a good lyric. She is a recording artist and has performed extensively with many jazz artists. She works frequently with pianist Fred Hersch and a number of other musicians, as well as with a number of contemporary ensembles.

She has led her own trio group and performed as featured vocalist and composer with numerous artists, and in many festivals in France, Norway and the U.S.

She has been on the faculty of the New England Conservatory since 1984, where she teaches voice, composition, and improvisation. Many outstanding performers are her former students, and she also has worked as clinician and artist-in-residence with students.

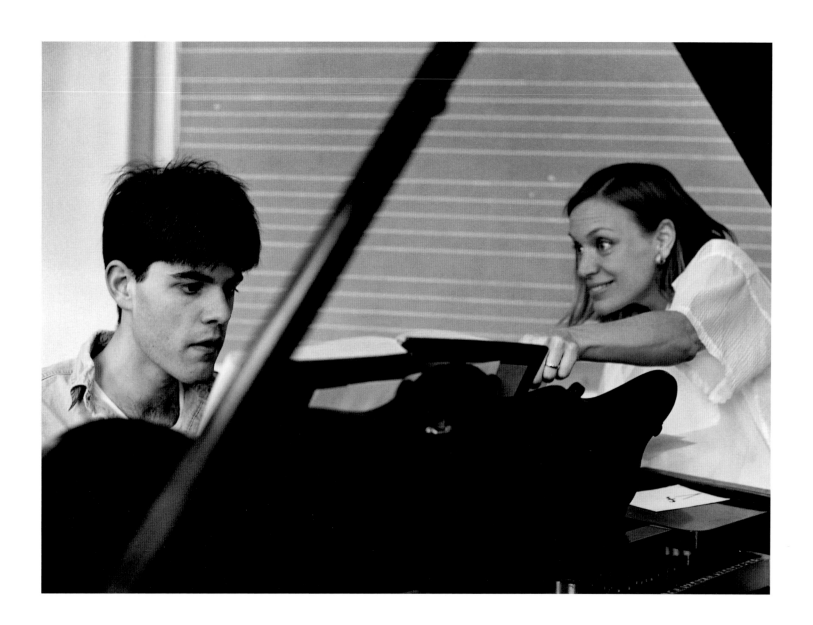

"What do you do to grow? You learn more by just sitting hours listening. Do you have the same sound in Mozart as in Mahler? As in Stravinsky? Listen with an ear that will design for you a color, a placement of sound that blends, reinforces, and punctuates. It's simply a matter of control and intelligent listening."

EVERETT "VIC" FIRTH

Legendary timpanist for the Boston Symphony Orchestra, Everett Firth is a renowned performer and teacher who has guided many gifted students and contributed extensive compositions and instructional material.

Firth's father was a trumpet player on the vaudeville circuit, and he encouraged his son to study arranging, as well as piano, trumpet, clarinet, trombone, theory, and drums (on which he concentrated from age 12.) As a teen he led his own eighteen-piece big band.

A few years later, at age 21, he became a member of the Boston Symphony Orchestra, and then at age 25, he was the youngest ever promoted to principal player.

Firth early on began making his own percussion sticks as he was dissatisfied with those available in his early years, and his company, Vic's Sticks, now is the largest manufacturer of the highest quality percussion products available.

He has been on the faculty at the New England Conservatory of Music and the Tanglewood Music Center for many years. Still playing magnificently, he recently retired from the orchestra.

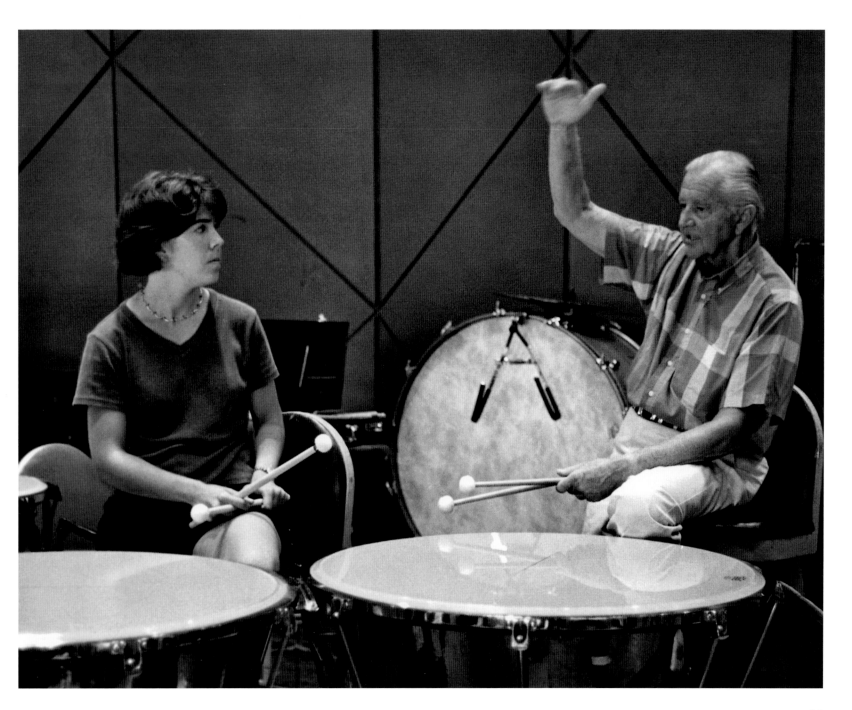

"Get low – feel the rhythm in your feet – and move!"

JOE GALEOTA

Joseph Galeota is seen here teaching the "Bamaaya" dance from northern Ghana. A professor in the percussion department at the Berklee College of Music, he started studying classical percussion early on with Rich Lapore, Stuart Smith and Alexander Lepak and later contemporary percussion under Gary Chaffee, and Dean Anderson. He then pursued a master's degree in ethnomusicology and African studies at the University of Ghana in West Africa, and at Wesleyan University.

In 1984 he pioneered a new business called JAG Drums, manufacturing professional West African Percussion instruments. JAG has become the industry standard for the Talking Drum and Eve Barrel Drums, and he has accommodated such venues as the Broadway production of *The Lion King* and the *Blue Man Group*.

Joseph is married to his West African wife, Vida, and they have two children.

He has been an educator of West African percussion and a performer throughout the U.S., Europe, and Africa since 1972.

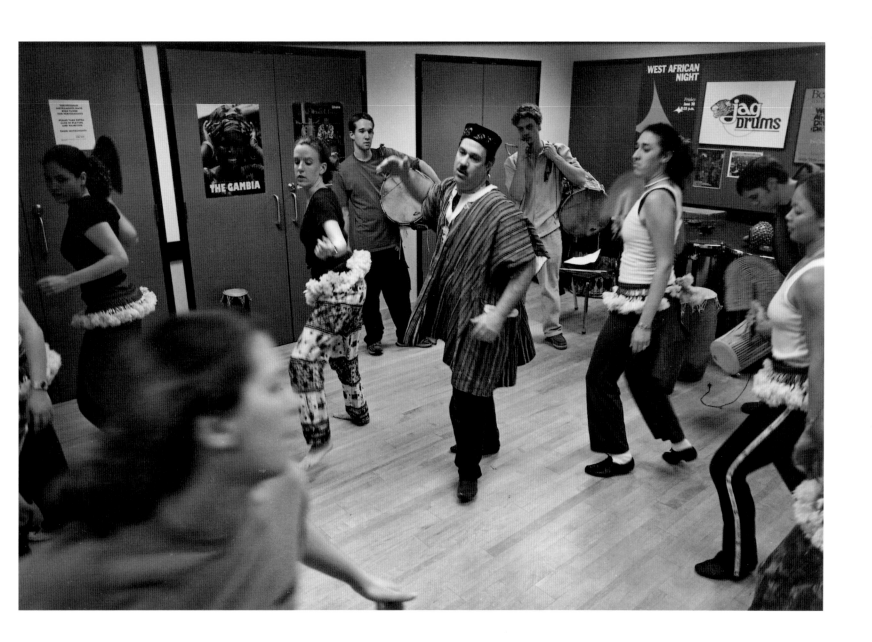

"The notes are alright and you play it well, but it needs warmth, it needs a soul – poetry. You don't give anything of yourself. And I must hear clarity – no schmutz!"

<div align="right">FELIX GALIMIR</div>

Violinist Felix Galimir was born in Vienna, Austria. But as Sephardic Jews, the family spoke Ladino, and in Germany were often taken as Italians. He studied violin with Adolph Bak and Carl Flesch, but was most influenced in chamber and contemporary music by Simon Pullman. In 1929 he founded the Galimir String Quartet with his three sisters. They concertized all over Europe, and were renowned for their interpretation of twentieth-century music, and it is said that no one did more to humanize the music of Berg, Schoenberg, and Webern than Felix Galimir.

In the dangerous days of Nazi Germany, on invitation of Bronislaw Huberman, Mr. Galimir went in 1936 to Israel as assistant concertmaster and soloist with the newly founded (by Huberman) Palestine Symphony Orchestra, now the Israel Philharmonic. Toscanini conducted the first concerts. In 1938 Galimir came to the U.S. and joined the NBC Symphony under Toscanini, reorganized his quartet, and played with many great artists.

Until his death in 1999 he was on the faculty of the Juilliard School, the Mannes College, City College, and the Curtis Institute, and he spent forty-three summers playing at the Marlboro, Vermont Music Festival.

His large teaching experience earned him a particular reputation as chamber music coach, invited to play and coach young musicians all over the U.S. and Canada. He has influenced three generations of musicians.

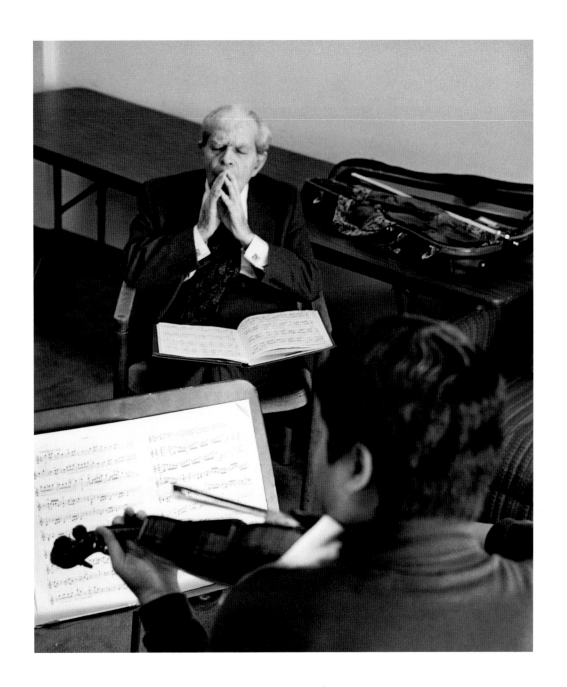

"It's just like sports or anything else. If you practice, you'll become better. And don't move about so much. You can 'emote' without doing all that. We don't even use that word in Europe!"

<div align="right">SIR JAMES GALWAY</div>

Sir James Galway was born in Belfast, Ireland and started out busking with a penny whistle in the train stations as a teen. Now, with unfailing taste, the great flutist crosses all musical boundaries with the classics, Japanese and Irish folk music, and jazz, and he is a popular favorite on television. Following positions with several international orchestras, and performing as principal flute with the Berlin Philharmonic, he began a solo career, and tours extensively throughout the world. He has shared the stage with many dignitaries, including President Clinton, Queen Elizabeth, and Pope John Paul II. Her Majesty honored him with a Knighthood in 2004.

As an instructor and humanitarian, he is a tireless promoter of the arts. He and his wife, Lady Jeanne Galway, an accomplished flutist in her own right, are known for their development of young flutists with their organization, Flutewise, a nonprofit that donates instruments to low-income students and young people with disabilities. Among others they've worked with kids from the Times Square Corps' after-school program that supports the arts community in New York, playing penny whistle and flute, and getting kids to display their own skills.

He is the author/editor of several books of instruction for the flute.

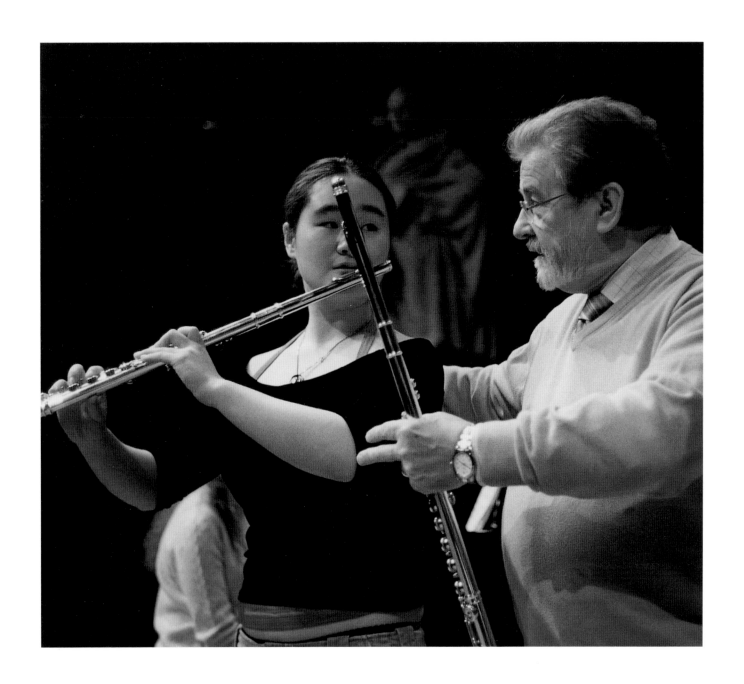

"What do you want to say? You've left a whole page of poetry but no place to take a breath."

<div align="right">BERNARD GREENHOUSE</div>

Cellist Bernard Greenhouse studied at Juilliard and made his New York recital debut at Town Hall to resounding critical acclaim. He then went to Europe for an audition with Pablo Casals, which resulted in two years of study with the great Spanish master. Casals wrote, "Bernard Greenhouse is not only a remarkable cellist, but what I esteem more, a dignified artist."

Since then Mr. Greenhouse has won a reputation as one of the major interpreters on his instrument, making appearances in most major cities of Europe and America in recital, with orchestras and chamber ensembles, and recording for CBS, RCA, Concert Hall, and the American Recording Society. He was recently awarded the National Service Award by Chamber Music America. Mr. Greenhouse plays the famed "Paganini" Stradivarius cello dated 1707.

He was cellist with the Bach Aria Group, and for thirty-two years with the Beaux Arts Trio, of which he was a founding member.

He has been a member of the faculties of the Manhattan School of Music and the State University of New York at Stony Brook, from which he received an Honorary Doctorate. He has recently retired Emeritus from his position as WCSL Professor at Rutgers University and also from the New England Conservatory; he now teaches master classes in the United States, Canada, and Europe.

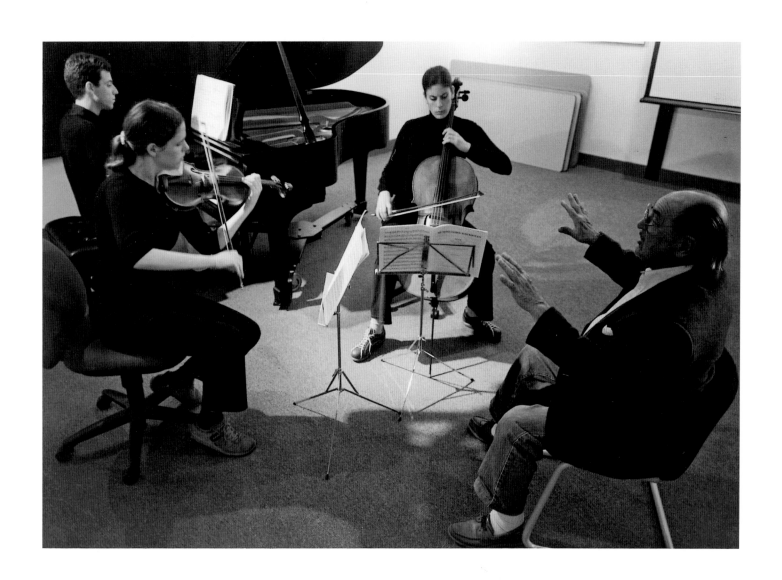

"Sometimes I get nervous the day of the shows, and my stomach hurts because I think I might mess up, but if I look at Roberta, I never mess up."

<div align="right">JESSAYA BROWN, a student</div>

Roberta Tzavaras Guaspari began her remarkable teaching career in three East Harlem public schools in 1980. Through her work she has become an international figure in the fight for public school music education.

In 1990, when funding for her teaching was eliminated, she joined with parents, teachers, and other volunteers to continue the program. They created a non-profit organization, now called Opus 118 Harlem School of Music, which has expanded to support a community music school serving thousands of low-income children both in and after school.

The 1996 documentary film, *Small Wonders*, featuring Roberta and her students, was nominated for an Academy Award. Her story was the inspiration for the film *Music of the Heart*, in which she was portrayed by Meryl Streep. Roberta is co-author of an autobiographical book of the same title. She has three children: Sophia, who is in high school; Alexi, a pediatrician; and Nicholas, who is the cellist of the Shanghai Quartet.

Among the many awards and honors she has received are honorary doctorates from the New England Conservatory of Music, S.U.N.Y, Fredonia, and Mount Holyoke College, as well as the American String Teachers Marvin J. Rabin Award, the Arison Award from the National Foundation for Advancement of the Arts, and CBS *This Morning's* "Woman of the Year."

Roberta resides in the East Harlem community in which she teaches. She wholeheartedly believes that violin instruction changes her students' lives, and that being a teacher remains the most noble of professions.

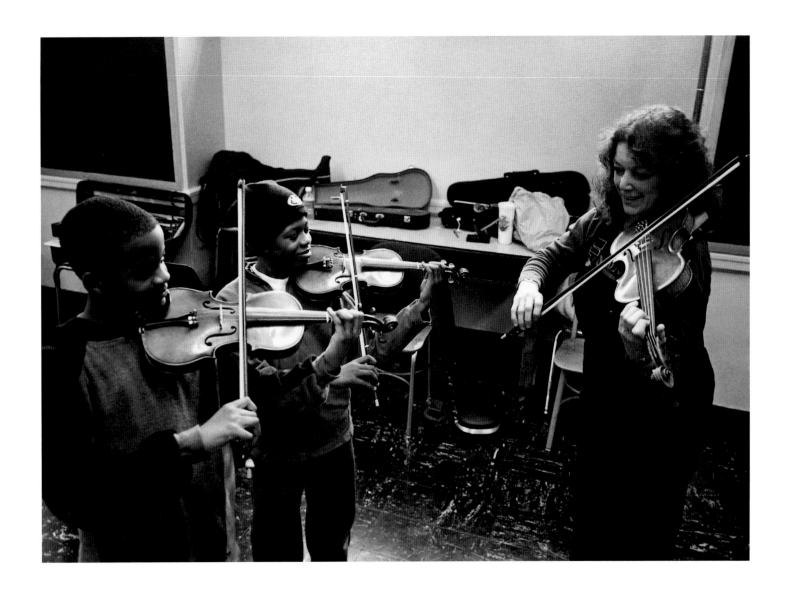

"It's a conversation. You're too polite.
Stay with it and let it be heard!"

MATT HAIMOVITZ

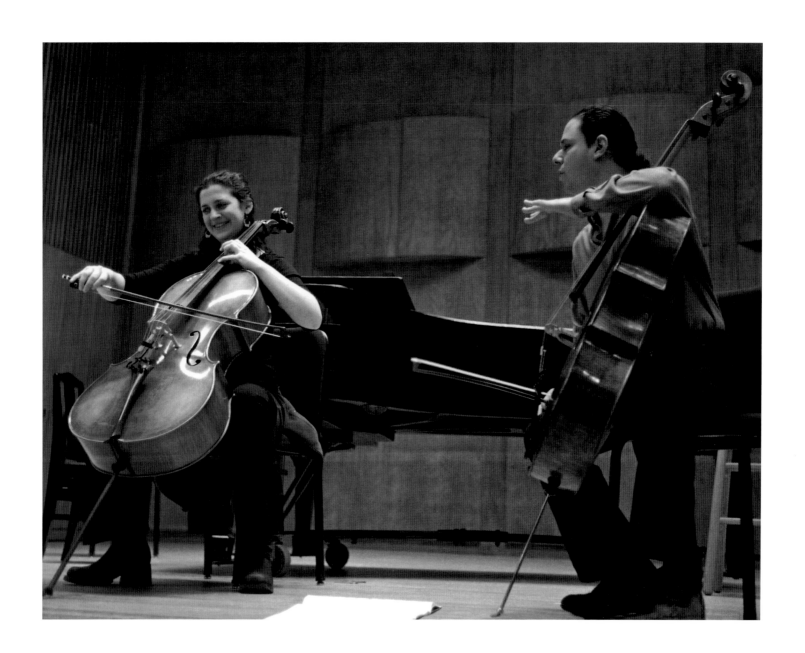

The cellist, Matt Haimovitz, is a musical pioneer. He has brought his artistry not only to concert halls, but to coffee houses, clubs, and rock joints. He grew up in a musical family. When Itzhak Perlman heard him in a master class, he invited him to play for the great cellist, Leonard Rose with whom he studied and then concertized with many of the great orchestras of the world. He was a student for a while at Princeton where he found himself trying to get to the heart of the compositional process, and he explored the contemporary cello repertoire, collaborating with many great composers of our time while looking for a sense of community with his music making. At Harvard he says he learned from other students what it means to make music. He also studied with Yo-Yo Ma and asked himself about the role of classical music in today's society as the classical recording industry was imploding. Besides having recorded for ten years on the Deutsche Grammophon label, he has made a recording of the Bach suites for cello on his own Oxingale label and expanded the repertoire with innovative commissions and recordings on this label, inviting composers to pair solo cello with non-traditional ensembles.

He wants a public who might never have heard the Bach suites to experience them without prejudice. He began to play them as well as his own notorious classic rock arrangements for solo cello in coffee houses, jazz, and rock clubs all over the U.S. These were "the least likely places you'd find a solo cello" he says, playing before people who came from many musical backgrounds, who were able to hear and enjoy Bach for the first time. He says Bach has a universal appeal to most people. He has thus allowed classical music to infiltrate popular culture, giving a sense of intimacy and spontaneity to the classical experience.

Born in Israel, Haimovitz has appeared with the major orchestras of the world, and he has been honored with many prizes for his playing. He has been written about in numerous publications including *The New York Times* and *The New Yorker*.

Along with his performing and recording, Haimovitz is committed to teaching. He is Professor of Cello at McGill University where he mentors an award-winning studio of young cellists and gives master classes in many locations.

"You come to a sound like it's completely unexpected – and you enjoy it!"

MATT HAIMOVITZ

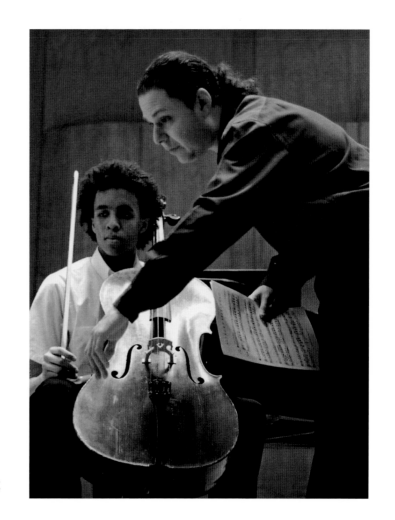

"My idea of immortality is continuing my music through students, but I try to help them develop their individual sound."

<div align="right">JIMMY HEATH</div>

Called a humble giant, tenor saxophonist Jimmy Heath is a brilliant jazz instrumentalist and composer and arranger. He is the middle brother of the legendary Heath Brothers.

He has performed with nearly all the jazz greats of the last fifty years from Dizzy Gillespie and Miles Davis to Wynton Marsalis. In his early 20s he acquired the nickname "Little Bird" because he could play alto exactly like Charlie Parker. He has made more than 100 recordings and written many compositions that have become jazz standards recorded by Cannonball Adderley, Clark Terry, Miles Davis, Ray Charles, and Dexter Gordon, and many others. He also composed seven suites and two string quartets.

"All I can say," said Dizzy Gillespie, "is if you know Jimmy Heath, you know Bop." "Jimmy is one of the thoroughbreds," said Miles Davis.

He was for eleven years Professor of Music at the Aaron Copland School of Music at Queens College, and conducts workshops and clinics in the U.S., Europe, and Canada.

Said to be a born teacher, he is a highly regarded educator, and is shown here in Jordan Hall of the New England Conservatory of Music, in class during a residency program at the Conservatory.

Even a bout with cancer failed to slow him down, and today he continues to teach. He has the rare ability and passion to convey musical knowledge, not only in an emotional way but in a clear and concise way as well.

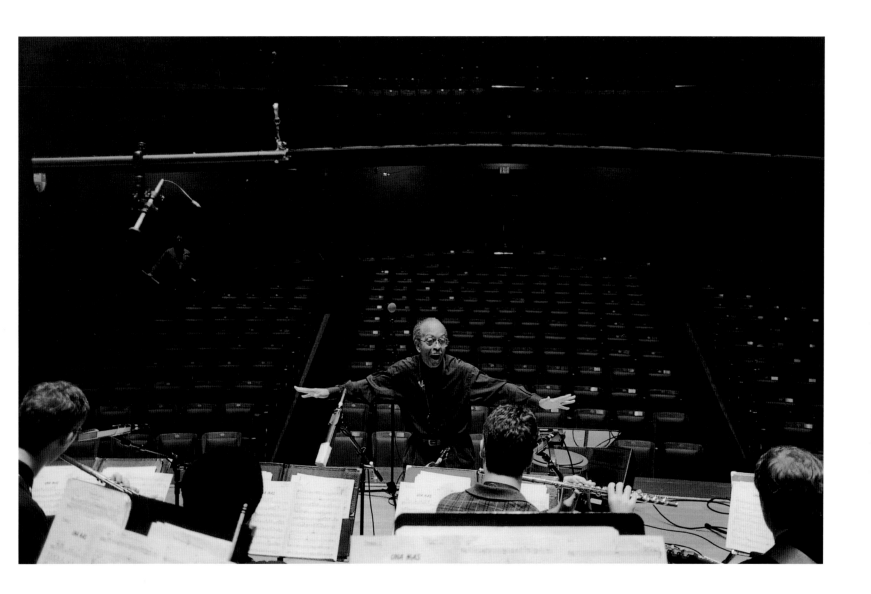

"The sheer physicality of the harp intrigued me. This thing was huge, and I learned to use it as a partner, a prop, and move around it. It's a lot like dancing."

DEBORAH HENSON-CONANT

Deborah Henson-Conant (seen on the left of the harp) is simply unlike any other performer. She tells stories with music and plays the electric, strap-on, solid-body harp like nothing seen before. It is exotic, sparkling jazz, and has won rave revues the world over:

> *"... she dresses like a showgirl, plays the pants off the harp and tells tall tales with the ease of a stand-up comic ..."*

> *"... plays gutsy, earthy solos I wouldn't have believed the harp capable of ..."*

> *"... utter sincerity, prodigious technique and courageous, elegant invention ..."*

She made her own path. "I think I sang before I talked." She was composing musical theater since age 12, studying classical harp, developing her own version of swing and Latin jazz, and connecting all three elements into a new genre of performance with a theatrical narrative of story-telling and humor . She has also explored the harp's system of roots in other cultures.

She's been featured guest artist with the Boston Pops and Pittsburgh Pops, jammed in concert with Doc Severinsen, performed new works with the New England String Ensemble and others, and is a prolific cartoonist and author of short stories, operettas, plays, musical theater and a screenplay, and lectured at the Paris Conservatory.

She says, "Don't think a harp teacher is the only one who can teach you to play the harp ... there are many other great teachers who can teach you music, performing, and self-expression. The instrument is just the vehicle. You need to learn MUSIC."

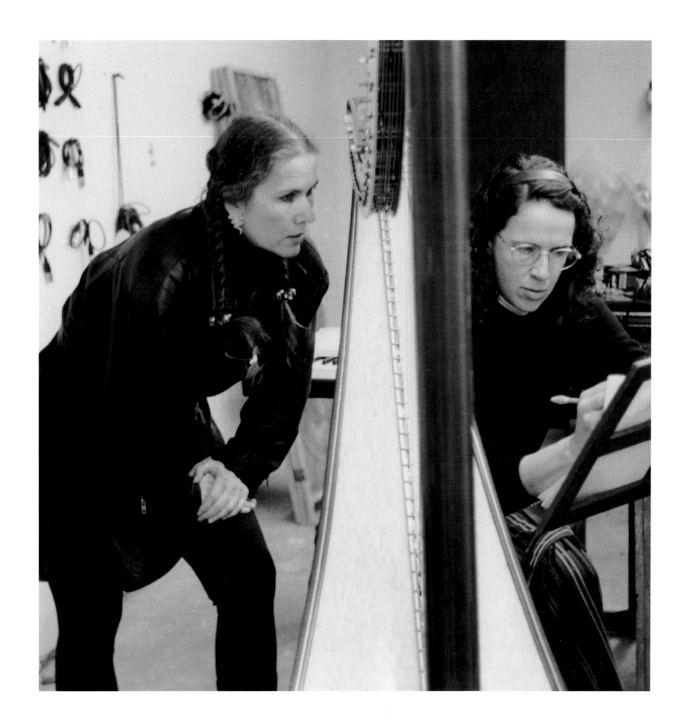

"There's something about being expressive, using your hands in direct contact with the strings. Talk through the harp with your hands, and let the vibrations go into your body."

<div align="right">ANN HOBSON PILOT</div>

Ann Hobson Pilot, the Boston Symphony Orchestra's principal

harpist, has been with the BSO for thirty-one years. She began her musical education at 6 with piano lessons from her mother, a concert pianist, and began harp at 14, playing at age 17 in Philadelphia at the Latin Casino behind acts such Johnny Mathis and Peggy Lee. At the Cleveland Institute of Music she studied harp with Alice Chalifoux, and became principal harpist of the National Symphony in Washington, D.C. until she came to Boston.

She was the only black player in the BSO for twenty years, and one of only four women. Now there are about thirty women. She has appeared as guest artist with a number of orchestras world wide, participated in music festivals, and is founder of the New England Harp Trio.

She has received numerous distinctions and made many recordings with the BSO, and recorded the harp concertos of Ginastera, Mathias, and Dello Joio.

Ms. Pilot is a faculty member at the New England Conservatory of Music and the Tanglewood Music Center, and she conducted master classes in China during the BSO's historic 1979 tour of the PRC.

She is involved in community affairs in Boston with her husband, Prentice, and together they formed the Boston Music Education Collaborative. Recently they took a trip to Africa in a project studying the origin of the harp. The project produced a documentary entitled *Ann Hobson Pilot: A Musical Journey*, which includes her solo performance with the National Symphony of Johannesburg.

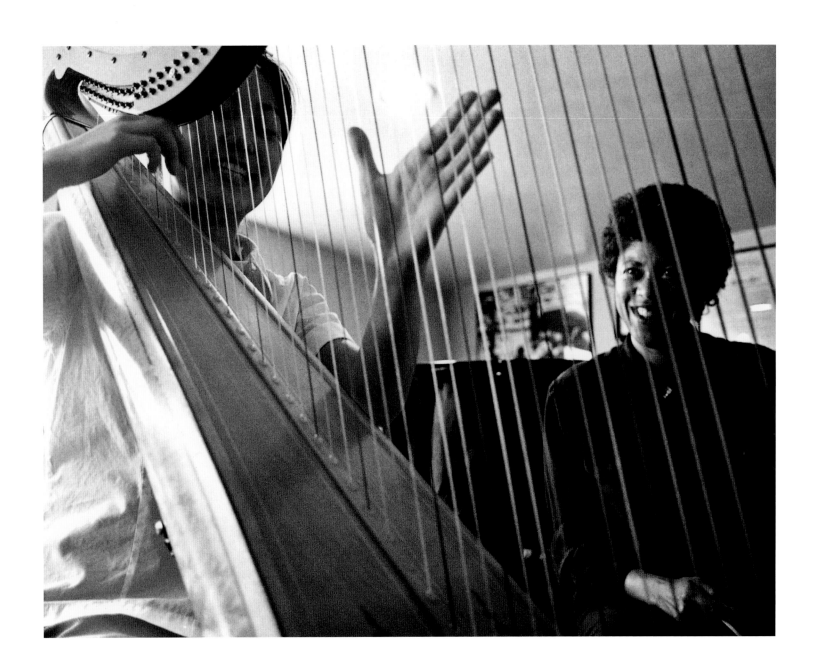

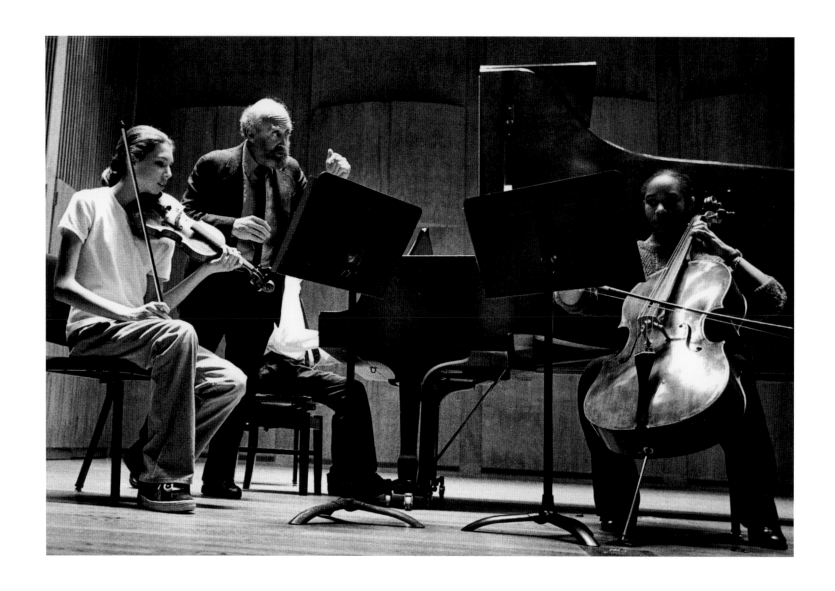

"As a teacher and mentor, I am committed to the possibility of nurturing the heart and soul and humanity of the young artists, and empowering their life-long contribution to the global community as artists, healers, and loving human beings."

<div align="right">LORIN HOLLANDER</div>

Lorin Hollander began playing the piano at age 4 when he studied with his father, Max, associate concertmaster of the NBC Symphony under Toscanini. His only formal instruction was with Edward Steuermann, but he also worked with Max Rudolf, Leon Fleisher, and Olga Stroumillo, and he made his debut in Carnegie Hall at age 11. He has since performed with virtually every major orchestra in the U.S. and abroad.

An influential philosopher and educator, he has lectured on a variety of subjects relating to music, the arts, science, religion, creativity, and psychology with an interdisciplinary, holistic approach, and has provided valuable frameworks for evaluating arts policies and programs for a number of institutes, congresses, panels, and medical centers.

In 1972 he became the first classical musician to perform on the streets of New York. He has developed unique programs and educational projects in which he coaches, conducts, and counsels faculty and young artists.

"Whether or not you are going to 'make it,' the process of learning to be on a team, where you can listen to other voices without losing your own, and listen to your own without drowning out others, can teach you a lot about what a life in music can be for you."

JOEL KROSNICK

Cellist Joel Krosnick was born in 1941 to a family of enthusiastic amateur musicians: his mother a pianist, his father a violinist/doctor, and his brother, Aaron, a professional violinist. By age 12 he had played most of the piano trio literature and by age 17 much of the quartet repertory with family and friends. He has been a member of the Juilliard String Quartet since 1974.

At Columbia University he got involved with living composers and became a founding member of the Group for Contemporary Music, and he has performed a six-concert retrospective of twentieth century music for cello and piano, as well as compositions of "Forgotten Americans." He performs as soloist, recitalist, and chamber musician all over the world, and with pianist Gilbert Kalish has performed recitals throughout the U.S. and Europe.

He is on the faculty of the Juilliard School, and members of the Juilliard Quartet spread the wealth of their spirit and experience working with young quartets. He has taught the cello and chamber music since his earliest professional life, and held professorships at the Universities of Iowa, Massachusetts, and the California Institute of the Arts. He has been associated with the Aspen Music Festival, Marlboro, the Tanglewood Music Center, Kneisel Hall, Yellow Barn, and the Piatigorsky Seminar at USC. He holds three honorary university degrees, among other notable awards with the Juilliard Quartet.

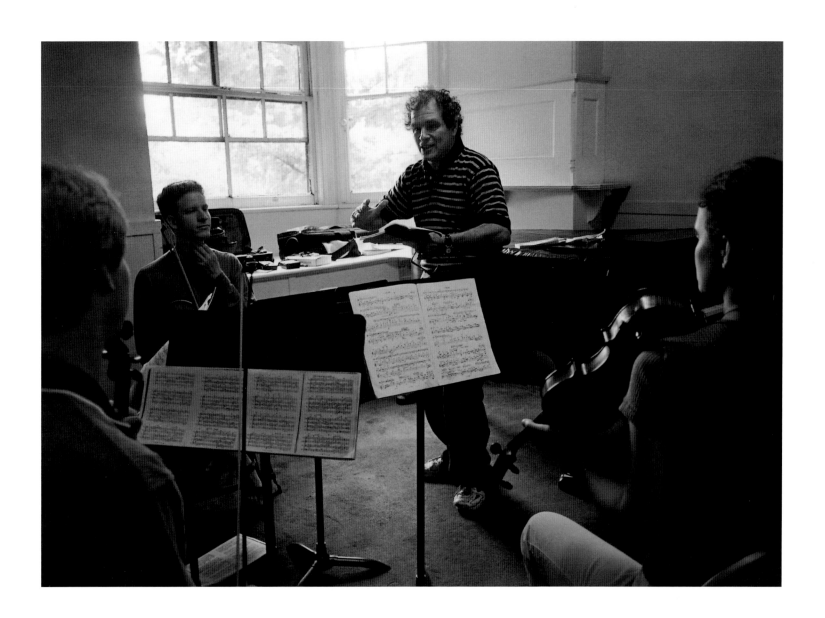

David Leisner is an extraordinarily versatile musician with a multi-faceted career as performing artist, composer, and teacher. Regarded as one of the world's leading classical guitarists, his superb musicianship and provocative programming have been applauded by critics and audiences everywhere. He has been acclaimed as a "triple-threat performer" by *The New York Times* and a "serious, exploratory and imaginative musician" by *The Boston Globe*.

Celebrated for expanding the guitar repertoire, he has introduced many important new works and has been a tireless advocate for neglected gems of the past. He is a featured recording artist for the Azica label, with highly acclaimed solo recordings of Bach, Villa-Lobos, contemporary music, Mertz and Schubert, and his own compositions. He has also recorded for the Naxos, Telarc, Koch, and Etcetera labels. Recent seasons have taken him around the US, to Europe, and to the Far East, and he has appeared as soloist with many internationally renowned orchestras. He is also a respected composer noted for the emotional and dramatic power of his music, with many publications and performances worldwide.

"You don't need much muscle to play guitar – you're moving bones – let your muscles take a vacation. Minimize muscular involvement, including your neck and stomach."

DAVID LEISNER

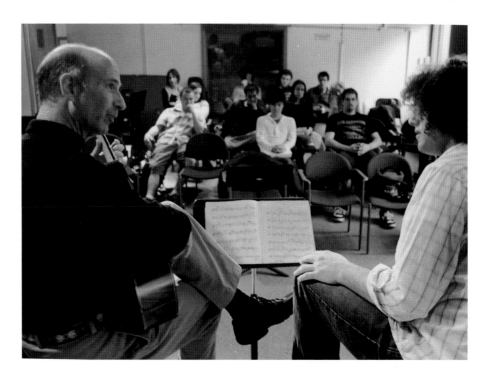

A distinguished teacher, Leisner has served on the faculty of the New England Conservatory, and he is currently co-chairman of the guitar department at the Manhattan School of Music. His lively master classes have been featured at many schools and music festivals around the world.

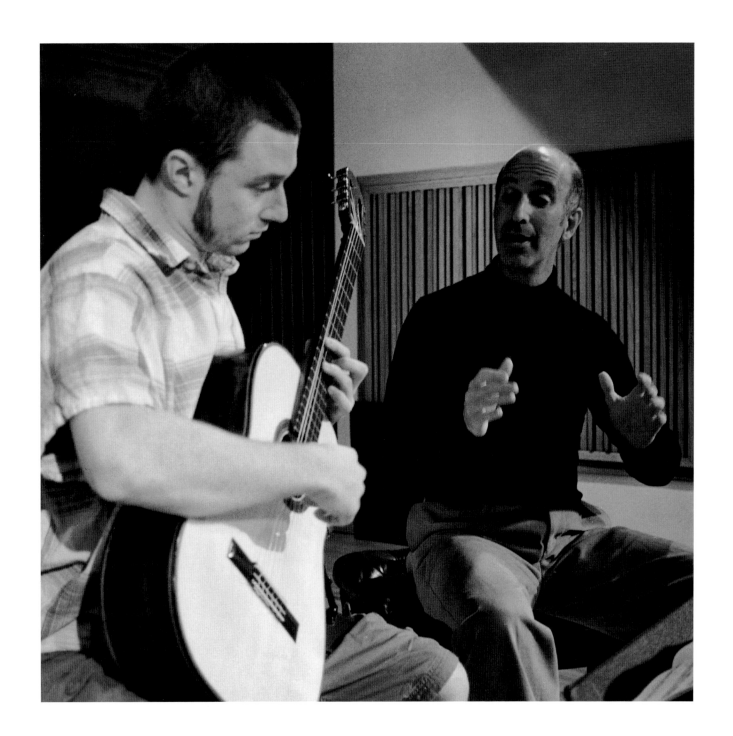

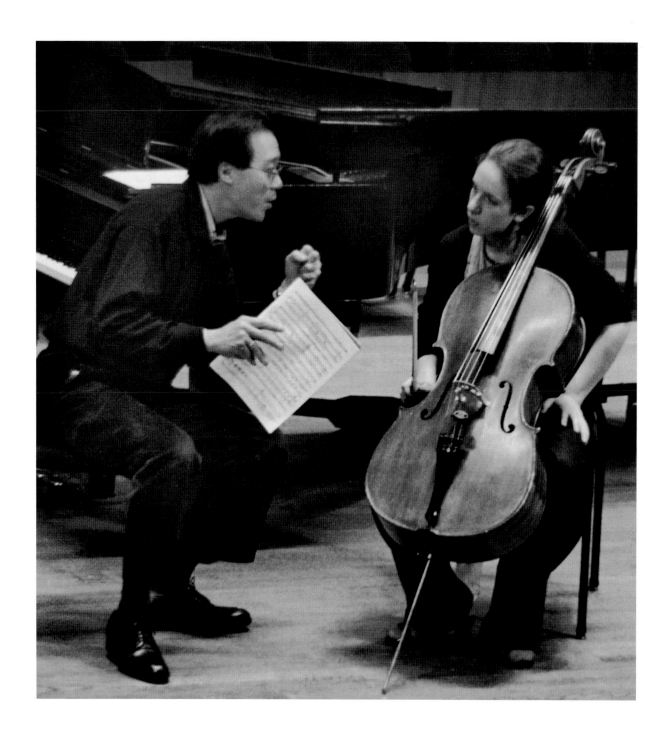

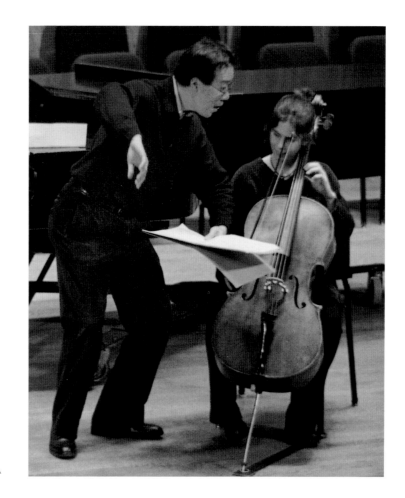

"It's not a problem.
It's an opportunity!"
Yo-Yo Ma

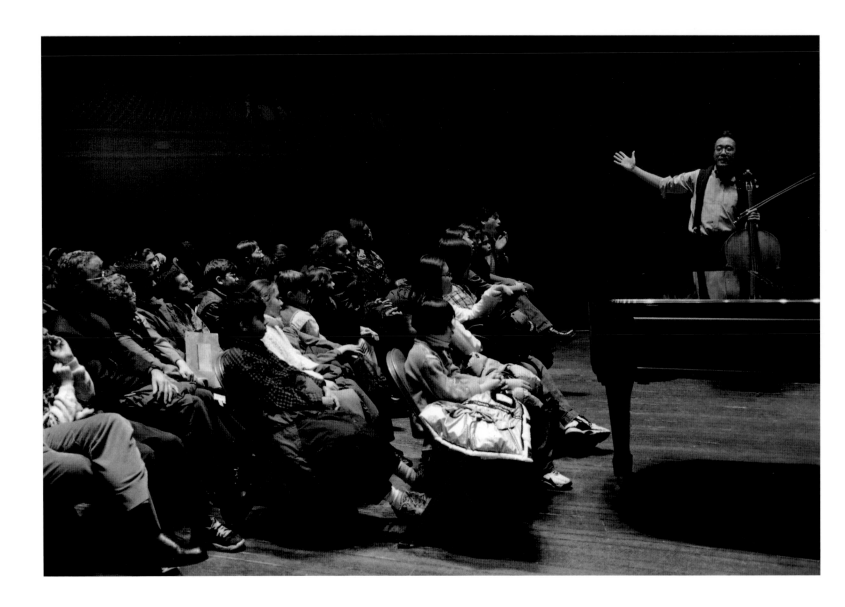

Cellist Yo-Yo Ma was born to Chinese parents living in Paris in 1955. He began studying cello with his father at age 4 and gave his first public concert at age 5. He played at Carnegie Hall at age 9. His principal teacher was Leonard Rose at the Juilliard School. He sought out a traditional liberal arts education at Harvard University and now lives in Cambridge, Massachusetts.

Mr. Ma has recorded over forty-five albums, won twelve Grammy Awards, and is probably the world's most sought-after cellist. His multi-faceted career is testament to his continual search for new ways to communicate by using music as a vehicle for the migration of ideas across a range of cultures throughout the world. He made recordings that defy categorization, among them *Hush* with Bobby McFerrin, *Appalachia Waltz* and *Appalachian Journey* with Mark O'Connor and Edgar Meyer, and *Piazzolla: Soul of the Tango*. Recently Mr. Ma established the Silk Road Project to promote study of the cultural, artistic and intellectual traditions along the ancient Silk Road trade route.

He maintains a balance between solo engagements with orchestras throughout the world and recital and chamber music activities.

Yo-Yo Ma is strongly committed to educational programs that not only bring young audiences into contact with music but allow them to participate in its creation. "One of the joys of working with children is that they are still unspoiled by cynicism," he says. The nurturing of young talent is a priority for Ma, and he takes time to conduct master classes in cities where he is performing. He appeared on *Mr. Rodger's Neighborhood* and *Sesame Street* to expose kids to the cello and to classical music.

"My Sicilian parents were unorthodox, and my neighbors in Brooklyn were funky people. One, a drummer, gave me love. Another, a shoe repairman, taught me to read music, and the furniture maker gave me a good tone on the clarinet. I now teach kids theory in my own unorthodox but very rigorous way."

<div align="right">JOE MANERI</div>

The maverick musician Joe Maneri says that he started playing because his father played, not professionally, but he liked the music he heard. Then, "I had a learning disability, and thought I was a failure. Quit high school at 15 and learned to play in clubs in Brooklyn. But then I studied with Josef Schmid, who was taught by Alben Berg, and I felt I'd overcome my disability. Later I started mixing jazz with 12-tone music." He went on to play sax and clarinet in many clubs as his underground fame grew, producing many ECM recordings, and playing for Ornette Coleman at Carnegie Hall, and he is widely known in Europe.

Although Maneri never went to college, he was hired by Gunther Schuller to teach at the New England Conservatory of Music. He became a gifted teacher of microtonal theory, a legendary figure for his ideas and influence on students and other musicians, and a great jazz innovator. His son, Matt, is a free-jazz violinist, sometimes playing six-string violin, and can be heard on seven of his father's CDs.

"He gives us the tools that we need to continue teaching ourselves, and to evolve as individuals with our own style."

MEGHAN BLISS-MOREAU, a student

"A master bassist with an authoritative sound and a thoughtful but adventurous style," bassist Cecil McBee was born and raised in Tulsa, Oklahoma. His musical career began in high school, where he played clarinet. By the age of 17, and after earning a Bachelor of Science degree in music education in Ohio, he began to experiment with string bass, playing local clubs with top groups.

His musical education in Ohio was interrupted by induction into the U.S. Army, where he spent two years as conductor of the 158th Band at Fort Knox, and developed a personal study of the possibilities of bass composition and improvisation. Because of this he decided to live in Detroit, then one of the most powerful jazz communities in the world.

Within a year he joined the Paul Winter Sextet and moved with them to New York. Since then he has worked, recorded and traveled worldwide with the best: Alice Coltrane, Miles Davis, Keith Jarrett, Wayne Shorter, Yusef Lateef, Freddie Hubbard, Chet Baker, Sonny Rollins, and the list goes on. The Cecil McBee Quintet is known for its imagination in modern jazz.

Mc Bee teaches a number of devoted and admiring students at the New England Conservatory of Music, and he is working on a book about technique for string bass improvisation.

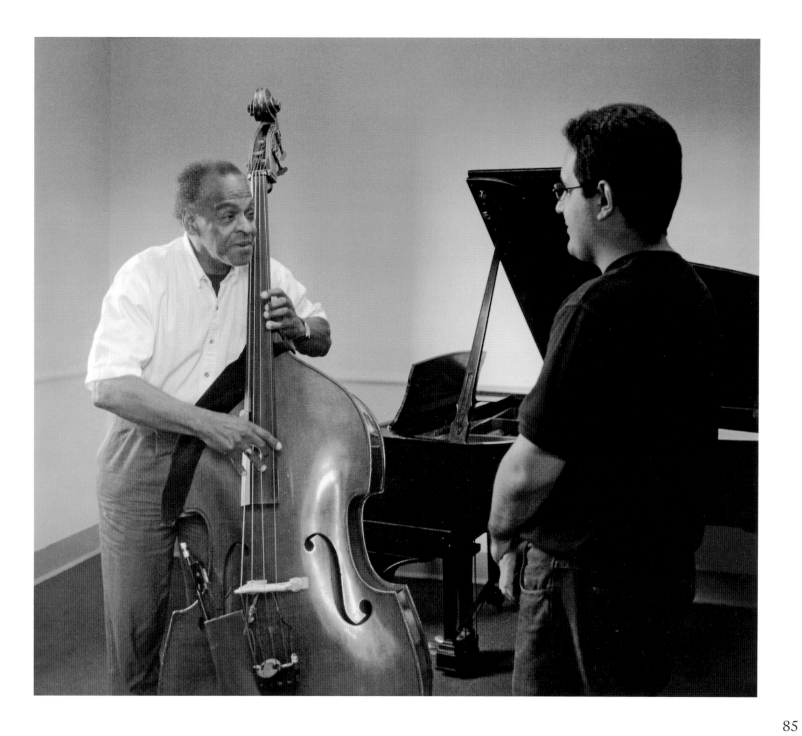

"You can be scared to death, as vulnerable as possible, but improvisation is simply taking steps, one note after another, and just seeing what will happen. Just dig inside yourself and you pull something out."

BOBBY MCFERRIN

The ten-time Grammy Award-winning Bobby McFerrin says of his teaching: "I guess I introduce students to another way of thinking about music from as many angles as possible, and getting people out of the boxes they've made for themselves." For the past several years, he has been the Creative Chair of the St. Paul Chamber Orchestra and teaches at the School of Music of the University of Minnesota.

His father was the first African-American man (Marian Anderson was the first woman) to sing a lead role at the Metropolitan Opera, and both parents were voice teachers. But he started his early career as a pianist and arranger. He did not start singing until he was 27, and his singing style is uniquely his own. It has the stylistic flexibility to sing nearly any kind of music and imitate every sound from a trumpet to flight of a bumble bee. He has collaborated with Yo-Yo Ma, Wynton Marsalis, and Chick Corea, among many other remarkable musicians.

Besides his solo concerts, he has worked as a conductor. "I pulled away from doing solo concerts because I was no longer scared to do them. I was looking for something intimidating, so I started conducting. But when I am alone on stage, the audience is like my orchestra, my 'voicestra,' and I can get them engaged in a very active way. Music makes a community. That's what we're doing, just making a community."

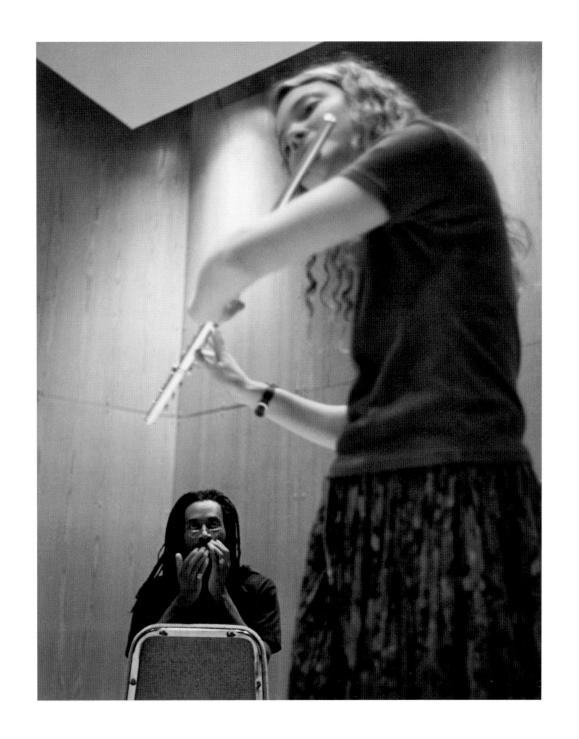

"Arusha, do you remember how you felt when you first began to play violin?"
"Yes, I do."
"What do you remember the most?"
"I took my violin home and I played my own music."

ANN MIKLICH and ARUSHA

Ann Miklich was presented with the Marilla MacDill prize for excellence in teaching at the Community Music Center of Boston (originating in 1910 as the South End Music Center and Boston Community Music School).

She is the chair of the string department at the school, and she also teaches at the Winchester Community Music School as well as in her private studio.

Ann Miklich is a freelance violinist in the Boston area and performs with Emmanuel Music, Boston Classical Orchestra, and the New England String Ensemble, and has performed with Monadnock Music, Alea III, the New England Bach Festival, and the Bard Music Festival.

She has also coached violin sections of the Greater Boston Youth Symphony Orchestra.

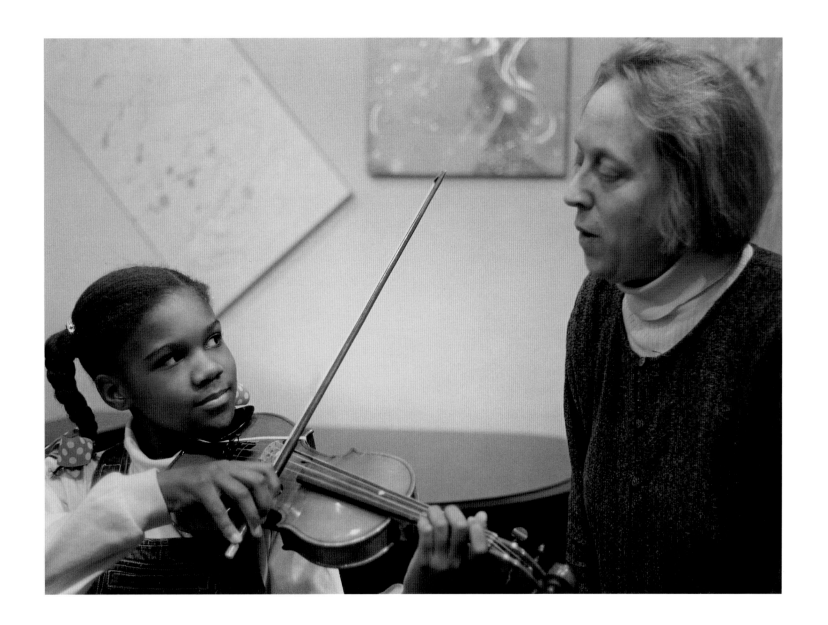

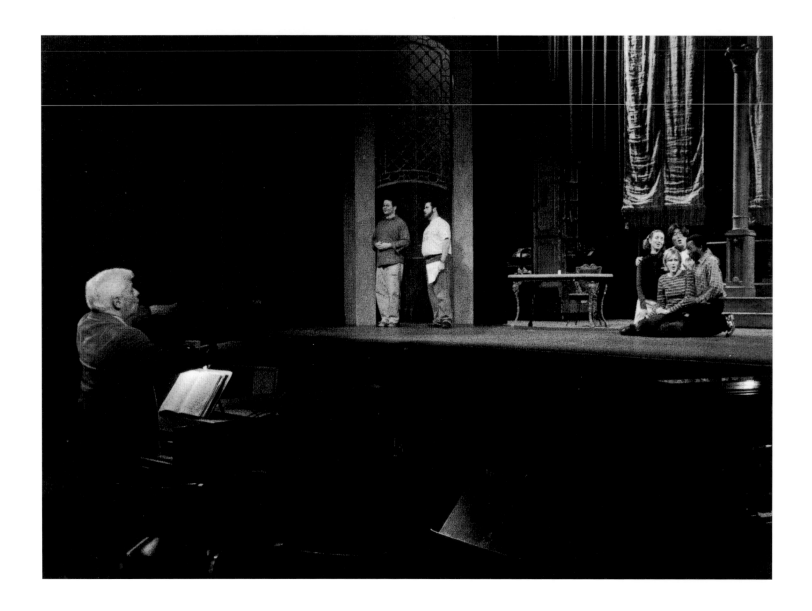

"How to work – how to prepare a role, how to audition, how to analyze a scene and a character, how to move in all kinds of ways to achieve physical control ... if you've learned the basics, you can fit yourself into any kind of production."

<div align="right">

JOHN MORIARTY

</div>

John Moriarty arrived at the New England Conservatory of Music as a student in 1946, and on graduating with highest honors he began a career as a solo pianist with recitals and concerto appearances in the U.S. and Europe. He came back to the conservatory as faculty to prepare singers for the famed Boris Goldovsky. "I started accompanying singers, and that exposed me to the dread opera disease!" Over the years, hundreds of his own students have passed through his opera training programs, among them Denyce Graves and Lorraine Hunt Lieberson.

He has been conductor and stage director with the Santa Fe Opera (where he worked with Stravinsky over the years), the Boston Conservatory Opera Department, Boston Lyric Opera, Opera Theatre of St. Louis, Lake George Opera, Wolf Trap, Oklahoma City Opera, the Colorado Symphony, and the Opera Company of Washington. He is currently Artistic Director Emeritus of the Central City (Colorado) Opera, where he was Artistic Director and its Principal Conductor from 1978.

He retired in 2001 as Chairman of the Opera Department of the New England Conservatory, and in retirement he wants to teach a French repertory class, help pianists working with singers, and teach diction. His book, *Diction*, a standard text about pronunciation of foreign languages for singers, is used nationally, although he is a strong believer in performing opera in English.

He has been the official pianist for the Metropolitan Opera regional auditions in Boston since they began.

"It was like a father-son relationship. I came to his Mecca of world-music, and he opened my mind to lots of different styles of music and cultures. It took time and dedication to absorb his concepts, but he truly led me out of the darkness."

<div align="right">

ELI KATZ, a student

</div>

Bob Moses is a composer, drummer, poet, painter, and dancer. Gil Evans said of him: "He creates a musical environment that is balanced between discipline and freedom, compositional design and spontaneous inspiration." He performs with his band, Mozamba and his percussion ensemble The Drumming Birds, and he has played in international music festivals. He also composes film scores, and consults for theater, dance, and the visual arts.

As a teacher he has done workshops as composer and arranger in the U.S. and Europe, and he is on the faculty of the New England Conservatory of Music, where he directs the Honors Jazz Ensemble. In his own words: "I try to break through fear, shyness, and ID-lock. Fear is the biggest obstacle to creativity. My goal is to chip away the stone around the heart without injuring the heart."

Originally from New York, he has performed and recorded with many stellar musicians: Charles Mingus, Gary Burton, Keith Jarrett, Dave Holland, and others.

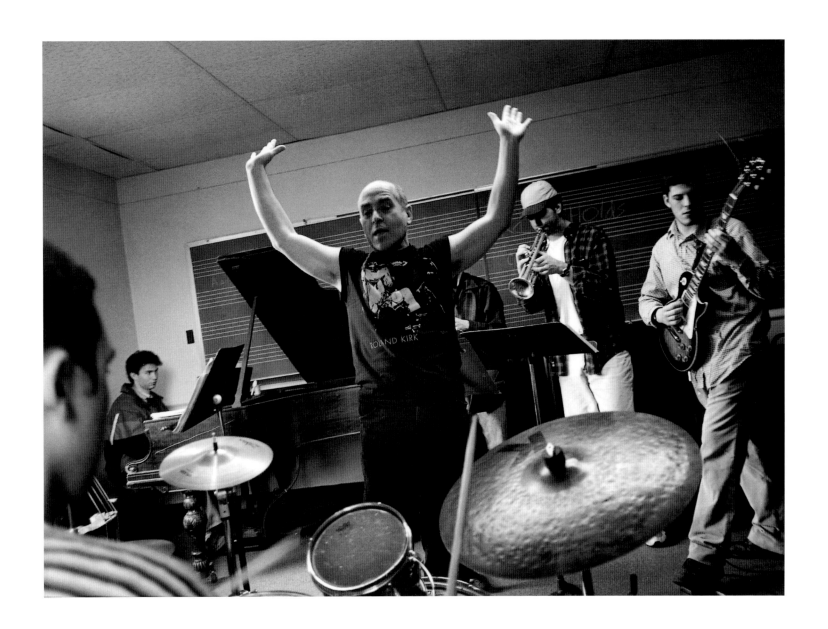

"No matter what you want to do, he can explain how to do it so you can play in a way you never thought possible. It's magical. I've never seen a teacher who gives so much to a student. You hold on for the whole ride so you can get out of him all he has to offer."

<div align="right">ASAF KALERSTEIN, a student</div>

George Neikrug, cellist, was a pupil of the legendary Emanuel Feuermann. But he credits his "genius" teacher, D.C. Dounis, with solving all his technical and musical problems. With this unique knowledge that was unknown to the musical world, Neikrug has devoted his life to making it work for him as a teacher to helping others develop their potential as players, and he has guided a few generations of students into professional careers.

He gives private lessons and master classes all over the world. He received the Artist Teacher Award in 1995 from the American String Teachers Association, and in 1996 was invited by Janos Starker to receive the Chevalier da Violoncelle award for outstanding lifetime achievement.

As a master cellist and bold musician, he is enormously respected. He had principal positions with the Baltimore, Pittsburgh, and Los Angeles Philharmonic Orchestras, and concertized as soloist widely in Europe and the U.S., earning praise from Bruno Walter, Leopold Stokowski, and Yehudi Menuhin. Neikrug appears on some important Columbia recordings made by Walter and Stravinsky.

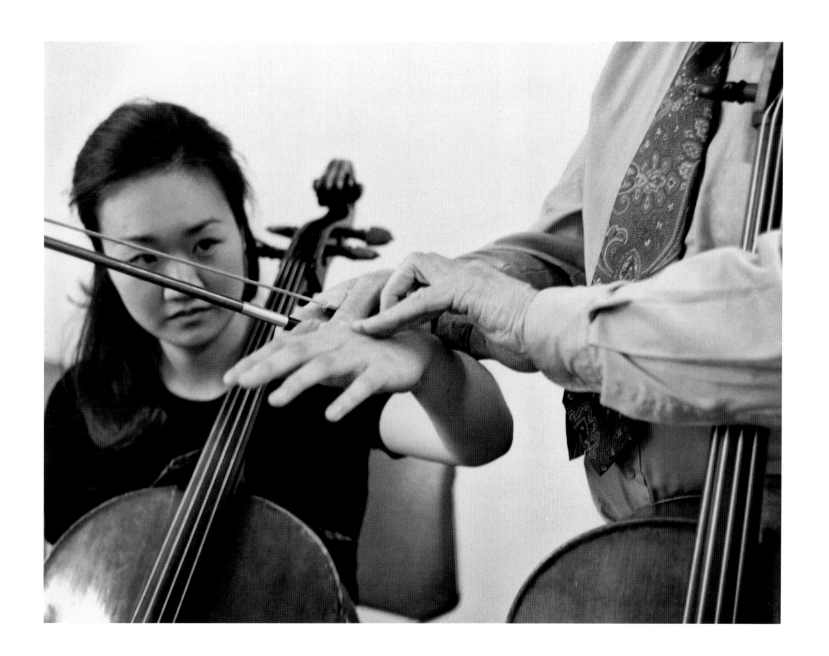

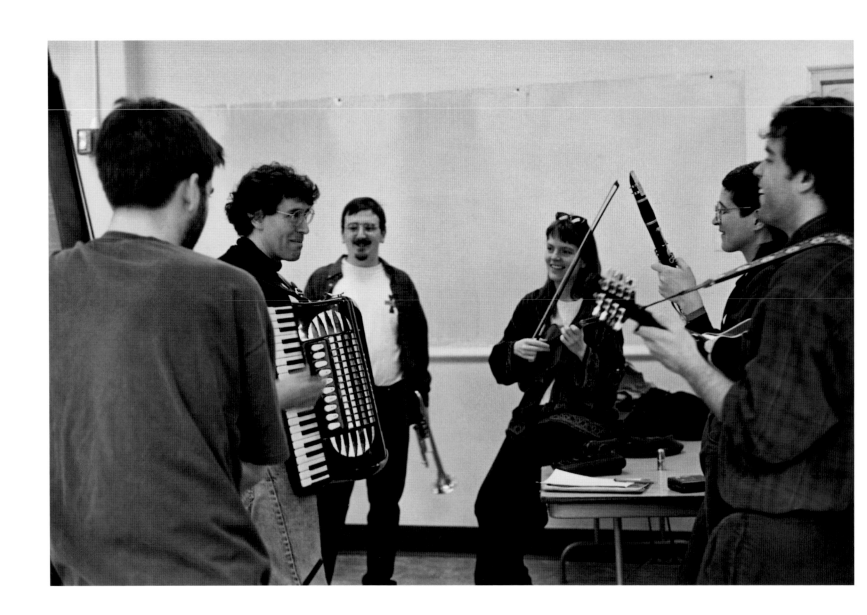

"Klezmer is a lot more than just a style of music. It's the atmosphere, the character, the personality of an entire community."

<div align="right">HANKUS NETSKY</div>

A multi-instrumentalist, composer and scholar, Hankus Netsky teaches improvisation and Jewish music at the New England Conservatory of Music in Boston. He is founder and director of the Klezmer Conservatory Band, America's premiere klezmer and Yiddish repertory ensemble. He has also taught Jewish music at Hebrew College in Boston and at Wesleyan University, and lectured extensively in the U.S., Canada, and Europe. Several of his essays on klezmer music have been published by the University of California Press.

Dr. Netsky has composed extensively for film and television, and collaborated closely with such artists as Itzhak Perlman, Robin Williams, Joel Grey, and Theodore Bikel. He has produced numerous recordings, including ten by the Klezmer Conservatory Band. He holds bachelor's and master's degrees from the New England Conservatory in composition, and a Ph.D. in ethnomusicology from Wesleyan University.

He has been the recipient of NEC's Outstanding Alumni Award and the Louis Krasner and Lawrence Lesser Awards for excellence in teaching.

"Hankus can do anything with music!" says one of his students. Netsky plays piano, accordion, saxophone, clarinet, and oboe.

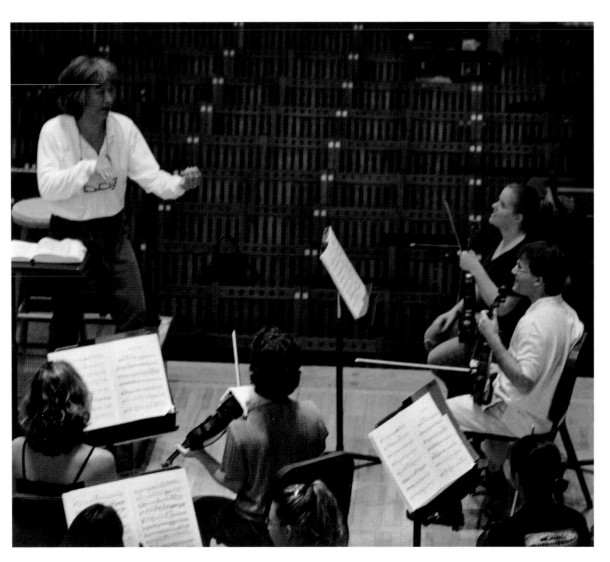

Seiji Ozawa

was born in China to Japanese parents. He studied music in Japan, going on to Europe for further study. While a student of von Karajan, he came to the attention of Leonard Bernstein, who made him assistant conductor of the New York Philharmonic for one year. It was Charles Munch who brought Ozawa to the U.S. to study at the Boston Symphony Orchestra's Tanglewood Music Center, where he won the Center's highest honor, the Koussevitsky Prize for conducting. He later studied with Munch in Berlin. He went on to win prizes internationally and conducting positions with several orchestras, and he co-founded the Saito Kinen Festival in Japan.

In 1973 he began his tenure with the Boston Symphony Orchestra, which he held for twenty-seven years. Serge Koussevitzky had served with the BSO for twenty-five years. In 2002 Ozawa assumed the post of music director of the Vienna State Opera.

At the BSO's Tanglewood Music Center (where this photograph was made in the new Seiji Ozawa Hall), he played a key role as both teacher and administrator at this summer training academy for young professional musicians from all over the world.

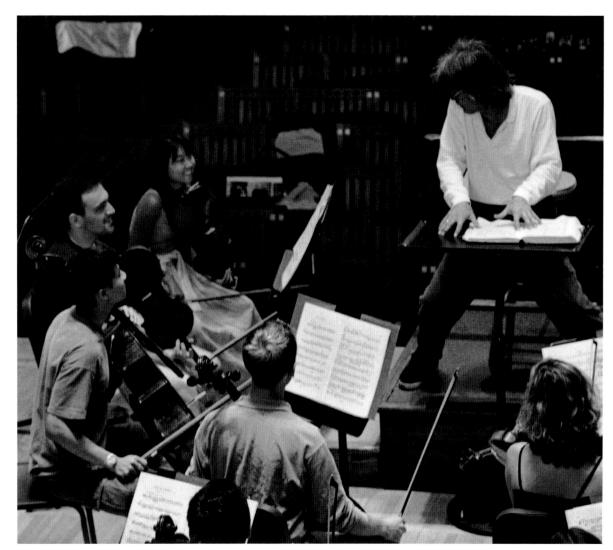

"I conceive my methods by instinct. And nobody will say, 'All students of Panula conduct the same way.' Each student is an individual. And no demonstrating, no imitating. They have to find the language, speaking with hands. It is a body language."

<div align="right">JORMA PANULA</div>

The conductor, composer, and scholar, Jorma Panula is credited with the recent proliferation of esteemed Finnish conductors who were his students: Esa-Pekka Salonen, Jukka-Pekka Saraste, Sakari Oramo, Mikko Frank, Osmo Vanska, Paavo Jarvi, Neema Jarvi, and on and on. The large number of Finnish conductors around the globe far exceeds what one would expect from such a small country.

Panula, who is known as a maestro of maestros, taught conducting at the Sibelius Academy in Finland for two decades. The Academy represents the peak of the Finnish pyramid of musical education in this diminutive country that has thirty symphony orchestras, eleven regional opera troupes and countless choirs and summer festivals. Music is said to be their national language. It may be the only country in the world where the annual opening day of Parliament ends with the legislators attending the opera!

Now retired, Panula is taking his idiosyncratic training all over the world, earning him cult status. It is said that he tries to arouse the right kind of instincts in his students. Says Panula, "We videotape every rehearsal, and the whole class criticize together. Like family. Not like competition. No more dictator conductors. So old-fashioned. Now team-work, and in a pleasant way, and then the musicians play with a better sound, more expressive."

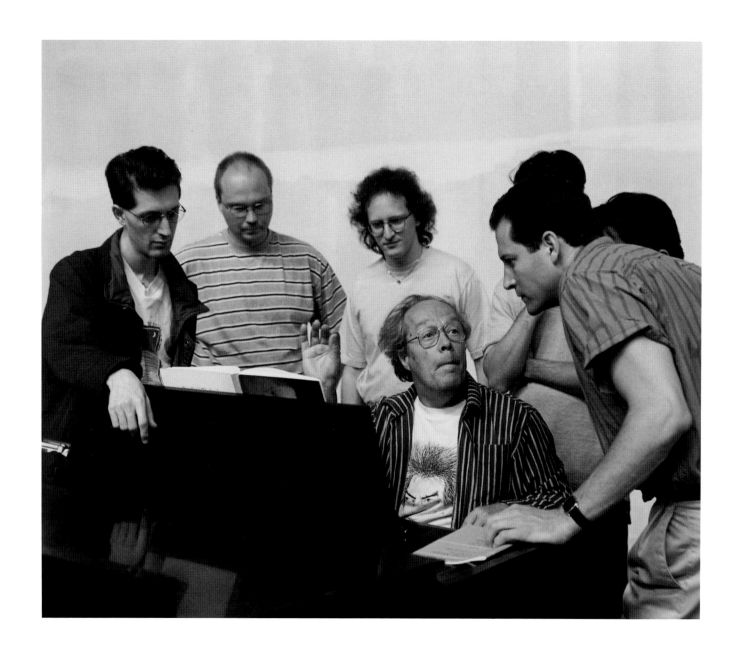

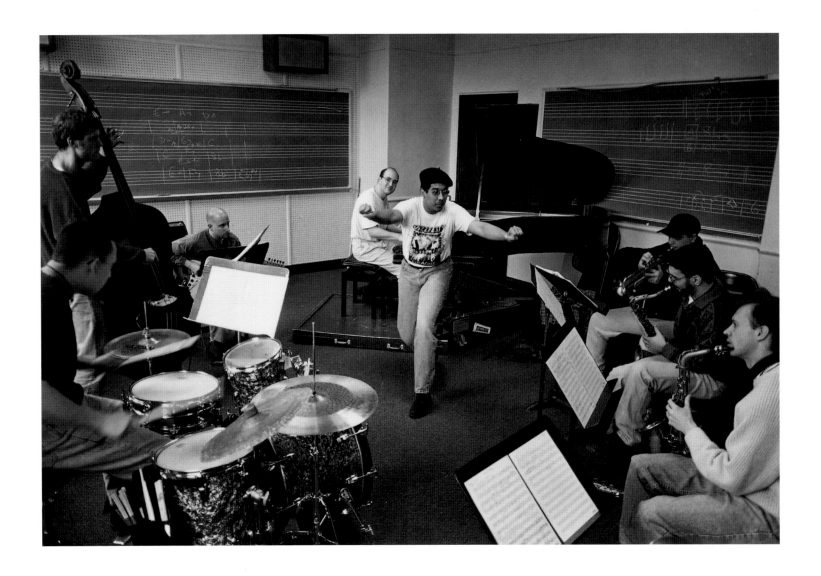

102

"He really cares that I learn. He's very clear – gives me a lot of rhythmic ideas. You can feel that energy when he teaches."

<div align="right">JOEY MAZZARELLA, a student</div>

Danilo Perez came from classical music, but says that the first piano music he ever heard that really turned him on to jazz was by Bill Evans. He has become one of the most influential pianist/composers in contemporary jazz since his tenure with Dizzy Gillespie's UN Orchestra. Said Herbie Hancock: "He is not afraid of anything."

He was the first Latin artist to tour with Wynton Marsalis's band, and the two performed for the 1996 Olympics, and at President Clinton's Inaugural Ball. He was the first jazz musician to perform with the Panamanian Symphony Orchestra. He is currently performing as a part of the Wayne Shorter Quartet and the Roy Haynes Trio, touring with other noted artists, and performing with his new group, Motherland Project, as pianist/composer.

He credits Thelonious Monk with "helping me find a middle ground, so I could play out of my background and also play jazz," and his album, Panamonk, exhibits these in perfect balance and has received rave reviews. He carries with him one of Dizzy Gillespie's philosophies: "No matter what happens in your career, you should always still be a person. You're no more special than anybody else."

He is a faculty member of the New England Conservatory of Music and the Berklee College of Music, teaching improvisation and jazz studies. He hosts clinics throughout the world, serves as Ambassador of Good Will for Unicef, and is a regular judge at the annual Thelonious Monk International Jazz Competions. He recently was presented with a Distinguished Alumnus Award from the Berklee College of Music, and was Keynote Speaker in January, 2007 for the International Association for Jazz Education.

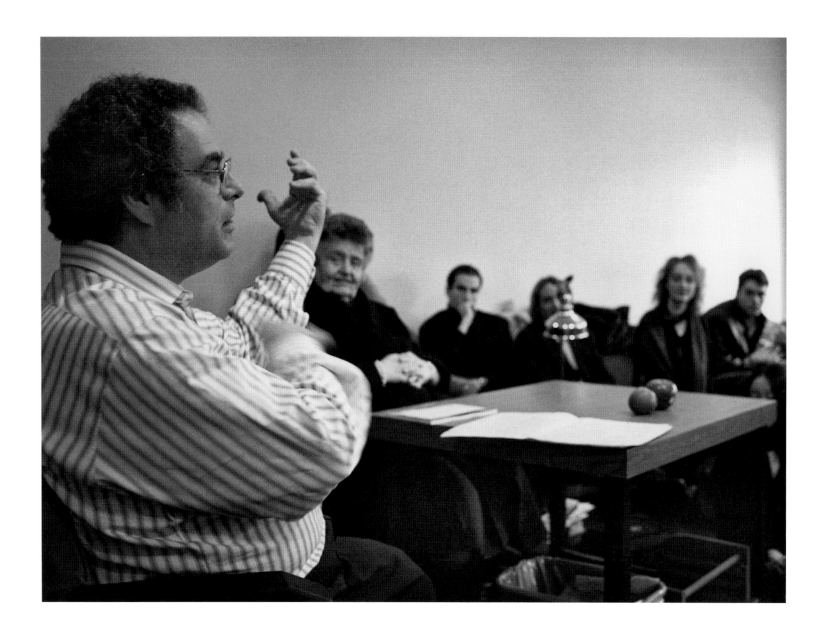

"Confidence is the most important thing. If you make a mistake it has to be done confidently. Whatever you do, it has to be done with great direction and meaning. Don't be careful. Careful is when you practice. Right now, take a chance."

<div align="right">ITZHAK PERLMAN</div>

Born in Israel in 1945 and completing his initial training at the Academy of Music in Tel Aviv, Itzhak Perlman came to New York and studied with Ivan Galamian and Dorothy DeLay at the Juilliard School of Music, and began a worldwide career as soloist. As the reigning virtuoso of the violin, he is beloved for his charm and humanity as well as his talent, and audiences the world over respond to the irrepressible joy of making music which he communicates.

Harvard, Yale, Brandeis, Roosevelt, Yeshiva, and Hebrew Universities are among the institutions that have awarded him honorary degrees. His presence on stage, on camera, and in personal appearances of all kinds speaks eloquently on behalf of the disabled and his devotion to their cause is an integral part of his life.

He has also appeared as conductor/soloist with many major orchestras, and he began as principal guest conductor of the Detroit Symphony in 2001. Of conducting he says, "When I am playing the violin, I am totally in control of what I am doing. When I am conducting, this is not always the case. I feel I have embarked on an adventure of discovery, and lucky to work with such wonderful orchestras."

In a relatively recent development in his career, Itzhak Perlman and his wife, Toby, founded a six-week institute to help train college- or conservatory-bound young musicians: the Perlman Summer Music Program. The PBS documentary, *Fiddling for the Future*, a film about this summer program, won him one of his four Emmy Awards. He has also won fifteen Grammy Awards.

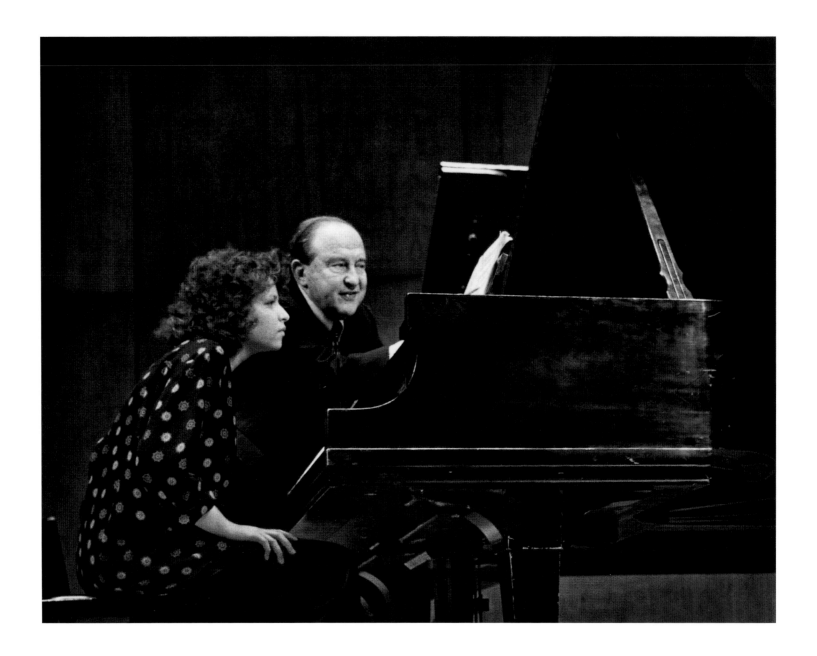

"What more beautiful thing could you say here? You must play as if you are playing it for the first time, and you yourself are surprised at that."

MENACHEM PRESSLER

Pianist Menachem Pressler was born in Germany and received most of his early musical training in Israel. His international concert career began when he won first prize in the Debussy Piano Competition in 1946, followed by a concerto debut with the Philadelphia Orchestra under Eugene Ormandy. He subsequently appeared with many of the world's leading orchestras.

In 1955 Mr. Pressler co-founded the Beaux Arts Trio, which has become one of the world's most enduring and acclaimed chamber music ensembles. He is a frequent guest artist with chamber ensembles, including the Juilliard, Emerson, Tokyo, and Guarneri String Quartets. Composer Virgil Thompson wrote of him: "He has taste and tone, poetry and precision, fire, temperament, delicacy, and an intellectual breadth rare among soloists."

Mr. Pressler is a much sought-after teacher. He is on the piano faculty of Indiana University's School of Music since 1955, where he holds the position of Distinguished Professor of Music, and he gives frequent master classes for chamber musicians.

"It's just like singing! You can express your feelings through the saxophone exactly the same way – a-a-a-a-a-a-h!"

<div align="right">KENNETH RADNOFSKY</div>

Saxophonist Kenneth Radnofsky teaches at The Boston Conservatory, New England Conservatory of Music, the Longy School, the Community Music Center of Boston, and privately (fifty-plus hours per week), besides designing and implementing a saxophone education program for Venezuela and Taiwan. He is "full-time everywhere."

He maintains an active career as soloist with leading orchestras and ensembles, including the Leipzig Gewandhaus Orchestra under Kurt Mazur, Dresden Staatskapelle Orchestra, Boston Pops, Taipei and Taiwan Symphonies, and New World Symphony. He has been on call as saxophonist for the Boston Symphony for thirty years.

Composers commissioned by Radnofsky (numbering over fifty) include Michael Gandolfi, Donald Martino, David Amram, Gunther Schuller, Milton Babbitt, and John Harbison. He has created a network of musicians as founder of World-Wide Concurrent Premieres, commissioning and performing some of today's finest composers.

His two daughters, whom he has described as his most important everyday teachers, are cellist Lauren and artist Julia. Embarking on their own careers, they share his joy of life and desire for world peace, in creating and sharing their art.

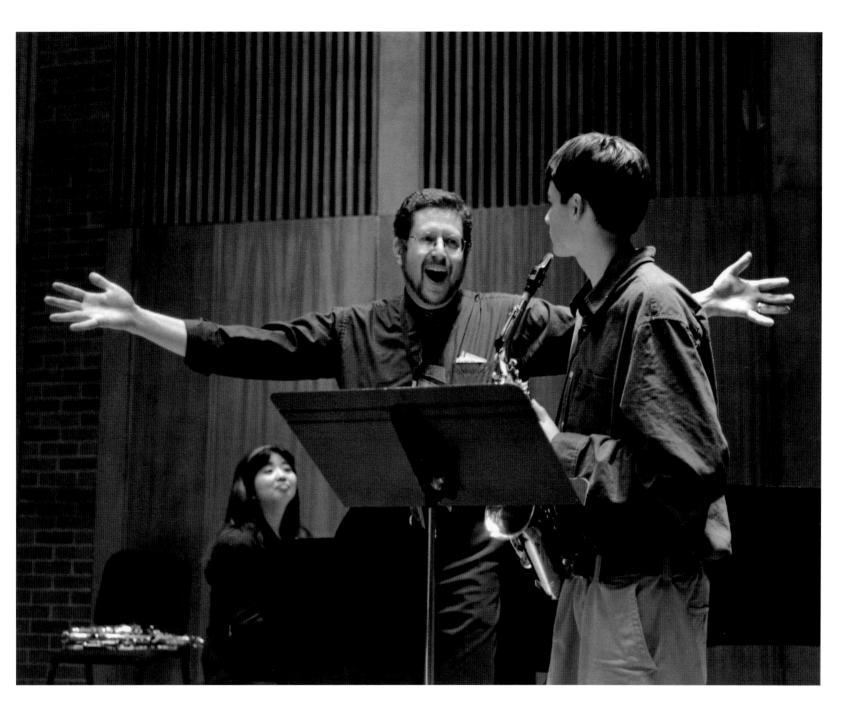

"Don't push the note out. Just open the door of the cage and let the bird fly out."

JOSEPH ROBINSON

Chosen by Zubin Mehta to succeed the legendary Harold Gomberg as principal oboe of the New York Philharmonic in 1978, Joseph Robinson has appeared frequently as soloist with this orchestra. He was previously principal oboe of the Atlanta Symphony. He is one of the two principal oboists remaining in the US who studied directly with Marcel Tabuteau, the great progenitor of the American School of oboe playing.

He won a Fulbright to study government support to the arts in Germany, and then received his master's degree in public administration from the Woodrow Wilson School of Public and International Affairs of Princeton University. He also lectures widely on orchestra governance as well as the interpretative art of music. He is author of several published articles stressing the need to reintroduce instrumental training in public schools and increase public interest in orchestras.

Through the Make-A-Wish Foundation, Mr. Robinson took up the request of Johanna Johnson, a 16-year-old oboe playing cancer patient who wished to sit with a great orchestra and play the oboe. He made it possible for her to sit with him and the New York Philharmonic, and to perform with the orchestra. *The New York Times* put their story on the front page of the Arts Section. Johanna is doing well today.

Mr. Robinson is a teacher of many prominent oboists. A native of North Carolina, in 1976 he created the John Mack Oboe Camp in North Carolina, one of the most successful specialty seminars of its kind in the world. He taught at the North Carolina School of the Arts. As president of the Grand Teton Orchestral Seminar, he helped develop unique orchestral training that inspired imitation in the first Master of Orchestral Performance degree in American higher education at the Manhattan School of Music, where he is department chair for the program.

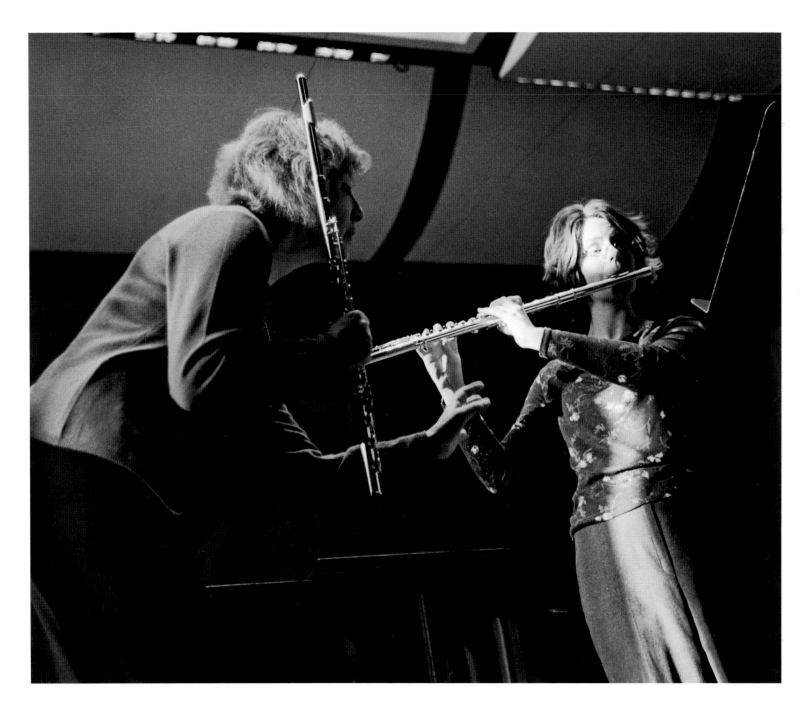

"Even the shortest note – if you throw it out into the space where you're playing – is alive. The flute can be as agile and as magical as a great dancer."

<div align="right">PAULA ROBISON</div>

Paula Robison was born in Tennessee to a family of actors, writers, dancers, and musicians. She learned to play the flute in her school orchestra, and when she was 12 she decided to become a musician. Study at the Juilliard School followed, with summers at the Marlboro Music Festival. When she was 20, Leonard Bernstein invited her to solo with the New York Philharmonic. She gave her New York recital debut under the auspices of Young Concert Artists and soon after became the first American to win First Prize in Flute at the Geneva International Competition.

Ms. Robison was a founding member of the Chamber Music Society of Lincoln Center and held the title of Artist Member for twenty seasons. During the same time she was co-director with Scott Nickrenz of the Chamber Music Concerts at the Spoleto Festivals, earning her the Adelaide Ristori Prize for her contribution to Italian cultural life. A passionate advocate for new music, Paula Robison has commissioned works by Leon Kirchner, Toru Takemitsu, Robert Beaser, Kenneth Frazelle, Oliver Knussen, and Lowell Liebermann.

Her teaching has taken her all over the world, and she has written five books on the art of flute playing. She holds the Donna Hieken Flute Chair at the New England Conservatory of Music.

"I learned how to be a father and a guru at the same time, which is a very difficult job, especially being in California with a teenager!"

<div align="right">RAVI SHANKAR</div>

"I am a disciple in the music room, and it is a situation of utter surrender and respect, and it's a beautiful relationship."

<div align="right">ANOUSHKA SHANKAR</div>

Ravi Shankar, the legendary sitarist and composer, was born in Varanasi, India. He studied for many years under the illustrious guru, Baba Allaudin Khan. He has done more for Indian music in bringing it to the West than any other musician. He composed extensively for film and ballet, and collaborated with such greats as Menuhin, Rampal, and Philip Glass. George Harrison of the Beatles turned him into a superstar in the '60s, since he was Harrison's guru on the twenty-string sitar. But Shankar left the pop world after playing at Woodstock, disillusioned by the drug scene, though his strong, close friendship with Harrison endured.

Menuhin said of him: "Ravi Shankar's genius and his humanity can only be compared to that of Mozart's."

Most of Shankar's students come to him when they are already skilled musicians, but his daughter Anoushka was a beginner at age 13, and has become a sitar virtuoso, a living legacy of her father's art. She is one of the few younger sitarists with only one teacher, her father. Besides his daughter, Shankar has taught generations of students.

"We have a format which takes many years to master after we learn from the guru. Then, it depends on the creativity of individual artists, and there's no end to that", he says. He has written a wonderful autobiography, *Raga Mala*.

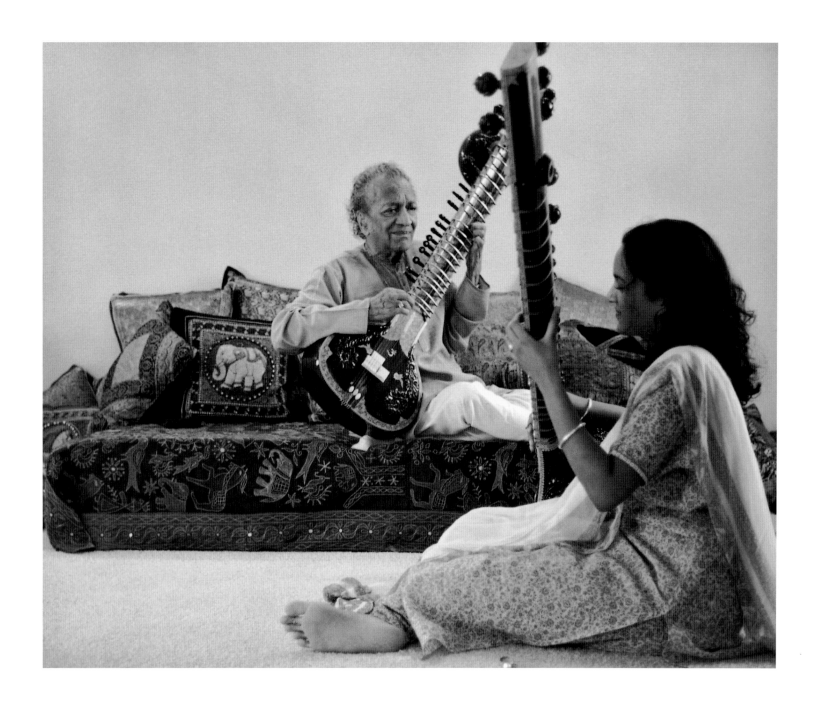

"Remember the 8 Ps (military-speak): Proper prior planning and preparation prevents piss-poor performance."

<div align="right">ROBERT SHEENA</div>

Robert Sheena has been the solo English horn player for the Boston Symphony Orchestra and Boston Pops Orchestra since 1994. His vocal style of playing has earned him numerous accolades – "spellbinding" *(The Berkshire Eagle)*, "... he gave the melody a lovely lift" *(The New York Times)*, and "beautiful solo playing" *(The Boston Globe)*. As a result of his mastery of this uniquely haunting instrument, Mr. Sheena has been honored with several premieres and appearances as soloist with the BSO and the Boston Philharmonic Orchestras. At Tanglewood in 1996 he was a featured soloist with the BSO in Andre Previn's *Reflections* (for solo English horn, solo cello, and chamber orchestra). In 1999 he performed the solo English horn line in Sibelius' Swan of Tuonela with the BSO in Symphony Hall. On Opening-Night at Tanglewood in 2000 he was again a soloist with the BSO in Aaron Copland's *Quiet City*. In 1998 David Alan Miller and the Albany Symphony commissioned a solo work expressly for him – Gabriel Gould's *Watercolors* – a work which they later recorded. He gave the premiere of Dan Pinkham's *Ode's for English Horn and Organ* at the American Guild of Organists convention in 1998.

Mr. Sheena is currently on the oboe and English horn faculty of Boston University, The Boston Conservatory and the Longy School of Music. A Tanglewood Music Center Fellowship program alumnus, he enjoys working with students through master classes and chamber music coaching at the TMC. With his esteemed colleague John Ferrillo he co-directs an intensive two-week summer workshop for young oboists at the Boston University Tanglewood Institute.

He is photographed here with student Ariana Ghez (now principal oboist with the Los Angeles Philharmonic) and with Seiji Ozawa (then conductor of the BSO) as he was sitting in on classes at the BSO's Tanglewood Music Center.

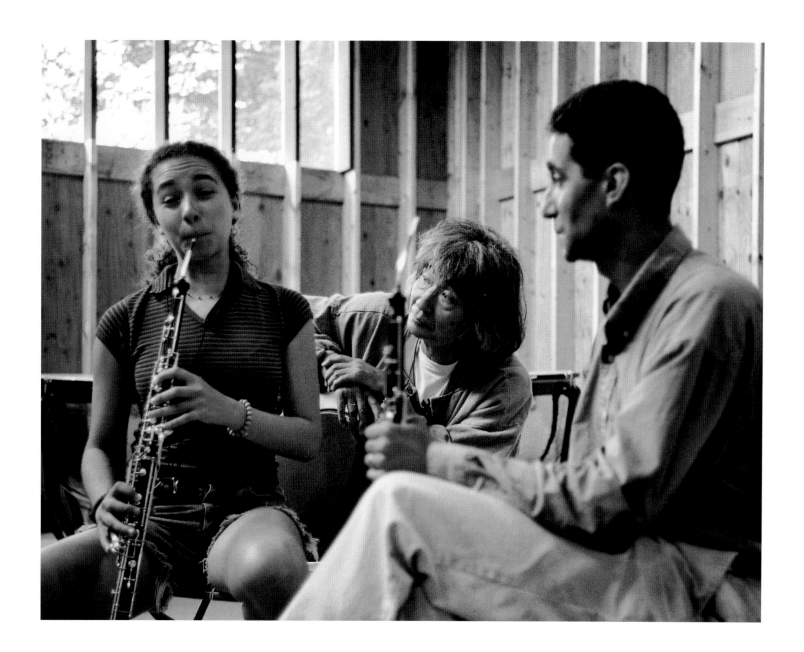

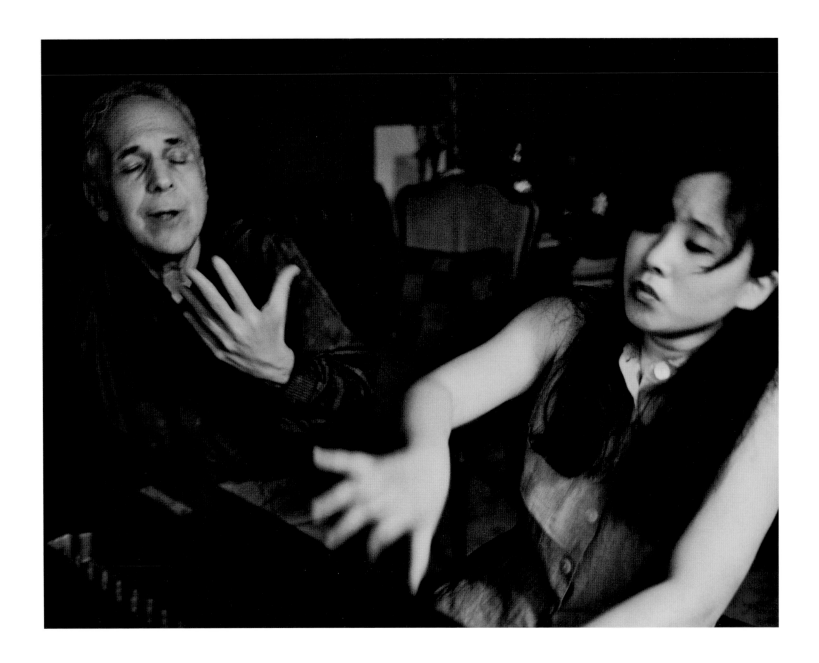

"He is a guiding light, a father figure, a model for us all. He's dedicated not only to the piano, but wants us to explore the worlds of literature, art, and current events. I'm very lucky to have him as my teacher."

<div align="right">

JONG GYUNG PARK, a student

</div>

Pianist Russell Sherman began piano at age 6, the result of a mother with "consuming temperament and raw passion," who pushed her five sons, having success only with Russell, the youngest. One of his most influential teachers, with whom he studied for fifteen years, was Polish-born Eduard Steuermann, himself a pupil of Busoni and Schoenberg. "Steuermann taught me how to think and feel ... a 'both person'." Sherman graduated from Columbia University at 19 (not letting studying interfere with the piano), and he has performed worldwide. He recently recorded the complete Beethoven sonatas.

He early on became active in New York's new-music scene, but in 1959 he essentially stopped performing professionally and began teaching, avoiding the celebrity circuit. As one reviewer says, "He continues to tease us with his absence."

Russell Sherman is one of the most important piano teachers in America. He has consistently produced some of the finest pianists around, helping his students become themselves, and thereby unique. He has taught at Harvard as an Artist-in-Residence at the University, and teaches at the New England Conservatory of Music.

He is also an intriguing writer. His book, *Piano Pieces*, is a compilation of personal anecdotes from his life as pianist and teacher. His wife, the renowned pianist and teacher, Wha Kyung Byun, was first his student, and she subsequently taught several students who have won international competitions.

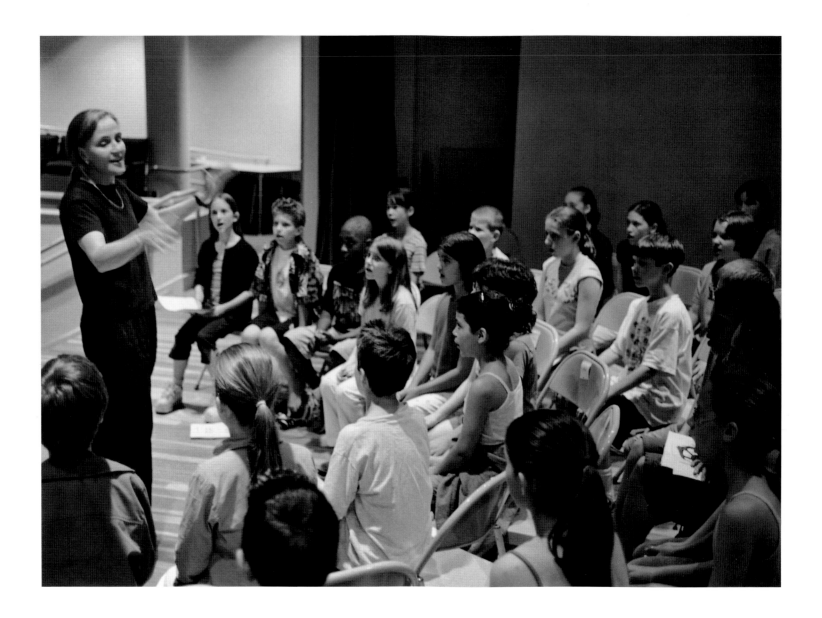

"I can't be your best friend because I'm not your age, and I can't be your mother 'cause I'm not. But we are a family in a loving world of music, and we are a deep family in that."

<div align="right">JOHANNA HILL SIMPSON</div>

PALS (Performing Artists at Lincoln School) Children's Chorus is best known to the local musical public for its regular appearances with the Boston Symphony Orchestra, but they have performed also with the Boston Pops, Boston Philharmonic, Boston Musica Viva, Boston Early Music Festival, Cantata Singers, Back Bay Chorale, and the Harvard-Radcliffe Chorus.

Their relationship with Seiji Ozawa and the BSO began in 1996. Ozawa says of Johanna Hill Simpson, PALS' founder and conductor emerita, "Jody really has a genius way of teaching, of being able to get inside the mind of a child, and know what will reach them." Simpson has served as guest conductor of other choral groups and is a frequent speaker and clinician throughout New England. The chorus has also appeared at the Kennedy Center in Washington, D.C., Tanglewood, and Carnegie Hall. They also give concerts featuring premieres of new works that they commission.

PALS is an inspiring group, with its high level of performance by youngsters coming from this one after-school program in a Brookline, Massachusetts school, and under Simpson's training the children have achieved excellence, receiving recognition for accuracy and beauty of tone. She has "taken children who are average singers to a level that is extraordinary," according to Liz Walker, TV anchor, who had a son in the group.

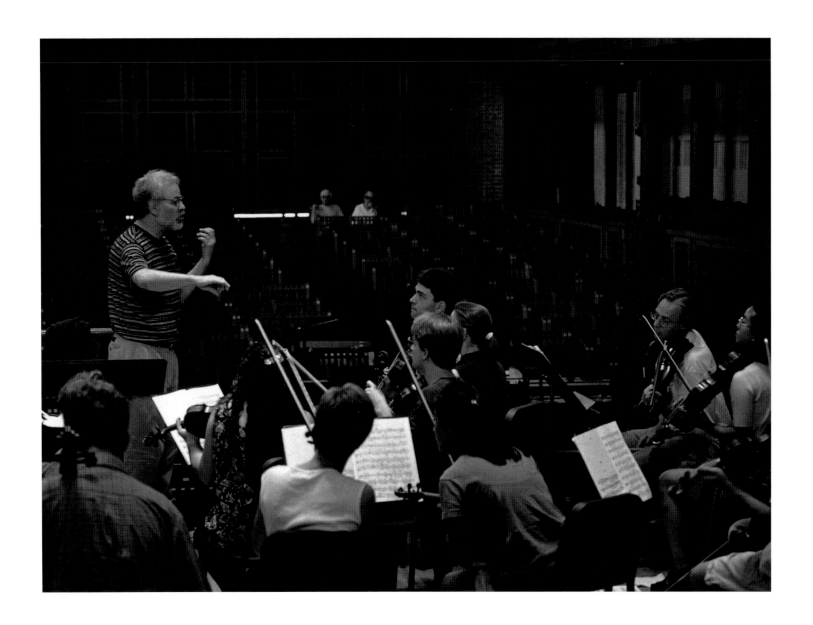

"The bow is equivalent to our breath. The strings are vocal imitators. Use the bow imaginatively and organically to make vocal shapes."

<div align="right">JOEL SMIRNOFF</div>

Violinist Joel Smirnoff was born into an eminent musical family in New York. His father, Zelly Smirnoff, played in the NBC Symphony under Toscanini and was violinist of the Stuyvesant Quartet, and his mother sang with the Jack Teagarden Band. When he was in his 20s, he was a dancer and member of the Chicago Chamber Ballet. He was for six years a member of the Boston Symphony Orchestra, after which he left to join the Juilliard Quartet as second violinist. In 1996, when first violinist Robert Mann retired, Smirnoff succeeded him as first violin.

In addition to his recordings with the Juilliard Quartet and solo recordings, Smirnoff has premiered many contemporary works, some composed for him. He has also become a sought-after conductor, and he has led the Norwegian Chamber Orchestra, the Basel Sinfonietta, the San Francisco Symphony, the New World Symphony, the BSO, and the Juilliard Symphony. He was soloist at Tanglewood, performing the Alban Berg *Violin Concerto*. He is also a fine jazz musician, appearing regularly as guest soloist with Gunther Schuller and the American Jazz Orchestra among other groups.

He is a faculty member of the Tanglewood Music Center, coaching students and conducting the orchestra there annually. He has been on the Juilliard School faculty since 1986, and chair of the violin department since 2000.

"I worry about the lack of curiosity I encounter in young musicians. It's amazing how little music they listen to. I tell my students when they are working on one of the Mozart horn concertos that they will get more out of it if they also listen to the piano concertos and to Don Giovanni."

JAMES SOMMERVILLE

James Sommerville, principal horn of the Boston Symphony Orchestra, came to the horn at age 11 in his native Toronto, when, in middle school, the only instrument left for him to chose was the French horn. When he entered university, the instrument became an obsession. He has a solo career as well, bringing him critical acclaim in appearances with major orchestras in Europe, Canada, and the U.S. He has toured and recorded extensively.

One critic says he has a "fearless and maverick approach to the horn and to music." Sommerville says, "The horn may not be the most difficult instrument to play, but it is the most precarious, and you need a willingness to laugh off some of the things that can happen."

He has performed as guest artist and faculty coach at many chamber music festivals. He also devotes his talents to the performance of early music on period instruments, and has commissioned many new works.

Sommerville has just been named the new music director of the Hamilton Philharmonic Orchestra in Toronto, while keeping his seat as principal French horn of the BSO.

He teaches at the New England Conservatory and at Boston University. He recalls how eagerly he went to concerts and explored music through recordings when he was a student, and encourages his students to do the same.

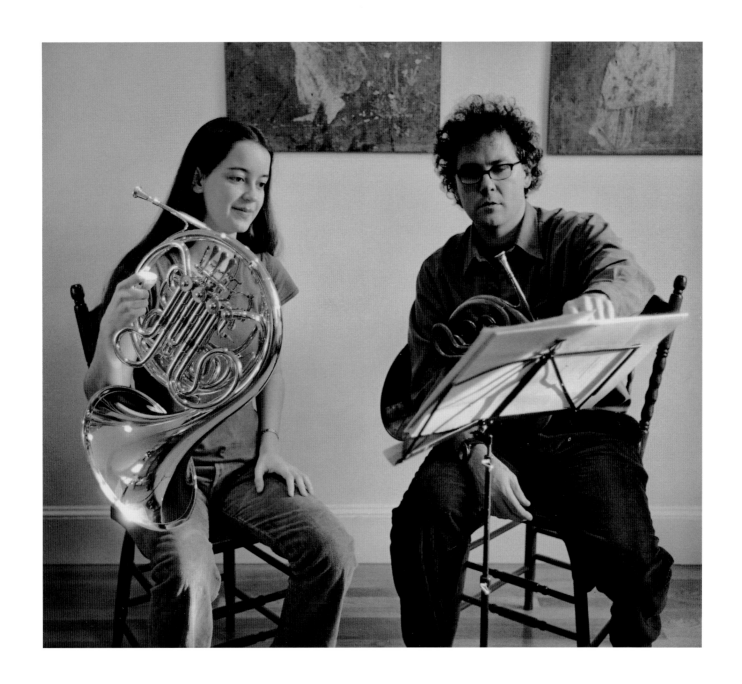

"To me teaching is not a profession but a way of life. I join my students in an exploration of our musical art as we strive together toward achievement of an inspired and yet stylistically viable performance."

<div align="right">ROMAN TOTENBERG</div>

Roman Totenberg is recognized not only as a great violinist but a brilliant

teacher. He was born in Poland, studied with Carl Flesch and Georges Enesco, and made his debut with the Warsaw Philharmonic at age 11. Then, after a Berlin debut, he was performing with every major orchestra in Europe. The family moved to Paris in 1933. In 1936 he was invited to perform at the White House for Franklin and Eleanor Roosevelt, and in 1939 made the U.S. his home.

He toured South America with Arthur Rubinstein and played joint recitals with Karol Szymanowski. He played a number of first performances of new works throughout his life. His work as a chamber music performer was widely acclaimed, and he has recorded under various labels.

As his reputation for concert performances grew, so too did his reputation for fine teaching, and in 1983 he was named Artist Teacher of the Year by the American String Teachers Association. He taught at Kneisel Hall, Tanglewood, the Aspen Music Festival, the Music Academy of the West, Salzburg's Mozarteum, Boston University, Mannes School of Music, Peabody Conservatory, and the Longy School of Music, where he was director for seven years.

His students are among the top violinists of their generation. In his eighth decade he was awarded the Metcalf Cup and Prize for extraordinary teaching. In his ninth decade he continues to teach. One writer said that Totenberg is a gift who keeps on giving. He says of himself, "I'm indestructible." He has three remarkable daughters, including Nina, the legal affairs correspondent for NPR, who says of her father, "He is an incredibly perceptive, sweet human being."

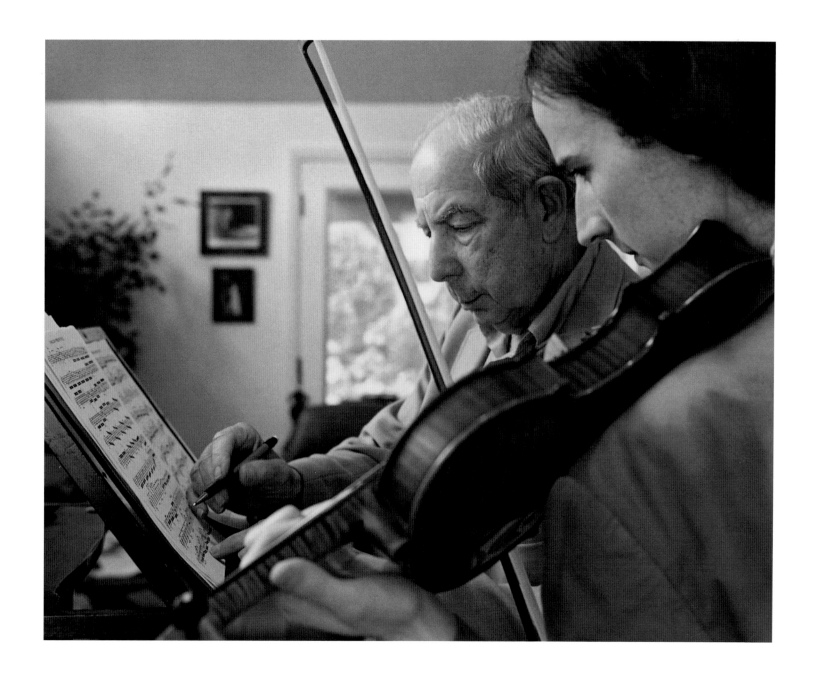

"Keep it intense – intensely beautiful. There are great lyrical opportunities for the tuba."

<div align="right">CHARLES VILLARRUBIA</div>

Tuba player Charles Villarrubia is currently a Senior Lecturer in Chamber Music at the University of Texas at Austin and a founding member of Rhythm & Brass. He received his bachelor's degree in music at Louisiana State University and his master's from Boston University. He has been a member of the Dallas Brass, the Waterloo Festival Orchestra, and the Tanglewood Music Center Orchestra.

In 1984 he was awarded first prize in the T.U.B.A. orchestral competition, becoming the first individual to win that award. He frequently performs with the Boston Symphony and Boston Pops orchestras and has recorded with the latter.

A staunch advocate of student involvement in chamber music, Mr. Villarrubia has authored a chamber music method book called *Team Play with Rhythm & Brass: A Guide to Making Chamber Music*. The book gives the student and educator a blueprint on how to start and maintain a successful chamber ensemble.

He has also written articles on the subject and been guest lecturer at the Mid-West Band and Orchestra Clinic and the Music Educators National Convention. He has premiered no fewer than five new works for the tuba, several of which he commissioned.

Mr. Villarrubia has appeared on four continents as guest clinician and performer for the Yamaha Corporation, and he has recorded on the Telarc, Angel EMI, d'note, and Koch labels.

He has been a faculty member at Boston University, The Boston Conservatory, New England Conservatory, and the Longy School of Music

"Be economical with your dynamics. Be stingy in the beginning so you have something left at the end."

<div align="right">ROGER VOISIN</div>

One of the most influential trumpet performers and teachers of the twentieth century, Roger Voisin joined the Boston Symphony Orchestra in 1935 at age 17 and became principal trumpet in 1952, performing with the BSO for thirty-eight years.

Voisin came to the U.S. as a child when his father, the trumpeter René Voisin, was brought to the BSO in 1928 by Koussevitzky. Voison claims that he and his father had their musical talent passed on to them from his grandfather. In fact, in France, his grandfather once bought trumpets for each of thirty-two orphans in a home and taught them all. Roger Voisin has had premiere performances of many major works and numerous solo and orchestral recordings.

He has had a long teaching career. He was with the BSO at the inception of the Tanglewood Music Center in 1940 and continues to serve on the faculty there, where this photograph was made. He was the primary trumpet teacher at the New England Conservatory of Music for thirty years, and professor at Boston University since 1975. His students (some 600) hold orchestra seats and prominent teaching positions in conservatories and universities all over the world.

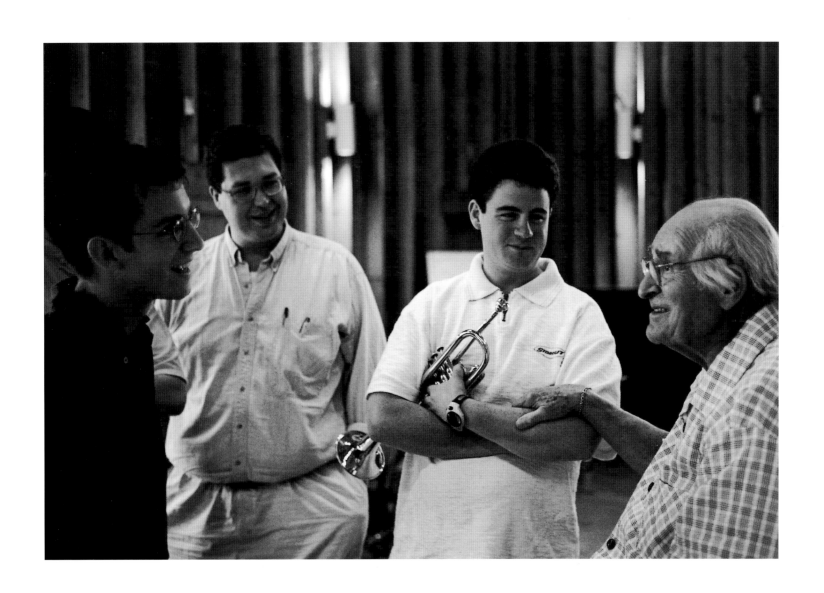

"But, Jonathan, your music is expressive! Why disguise and complicate it with alien ideology and mechanistic schemes?"

YEHUDI WYNER

Awarded the 2006 Pulitzer Prize for his *Piano Concerto: Chiavi in Mano*, Yehudi Wyner, the composer, pianist, and teacher, is one of America's most versatile musicians. His father, Lazar Weiner, was the preeminent composer of Yiddish Art Song as well as a notable creator of liturgical music for the modern synagogue.

His compositions include over sixty works for orchestra, chamber ensemble, voice, piano, and music for the theater, as well as liturgical services for worship. He has received commissions from Carnegie Hall and The Boston Symphony, among many others, as well as prizes and awards. They include the Grammy, Rome Prize, two Guggenheim Fellowships, the Institute of Arts and Letters Award, and the Brandeis Creative Arts Award, and he currently serves as vice-president of the American Academy of Arts and Letters.

He has been composer-in-residence at the Santa Fe Chamber Music Festival, the American Academy in Rome, the Rockefeller Center at Bellagio, Italy, and the Atlantic Center for the Arts. He was on the faculty of the Boston Symphony's Tanglewood Music Center from 1975-1997, and taught at Yale from 1963-1977, where he served as head of the composition faculty. In 1978 he became Dean of the Music Division at SUNY Purchase, where he taught for twelve years. He was a guest professor at Cornell University in 1985 and since 1991 has been a frequent visiting professor at Harvard University. From 1991-2005, he held the Walter W. Naumburg Chair of Composition at Brandeis University, where he is now Professor Emeritus.

Many compositions were created for the composer's wife, the singer and conductor Susan Davenny Wyner.

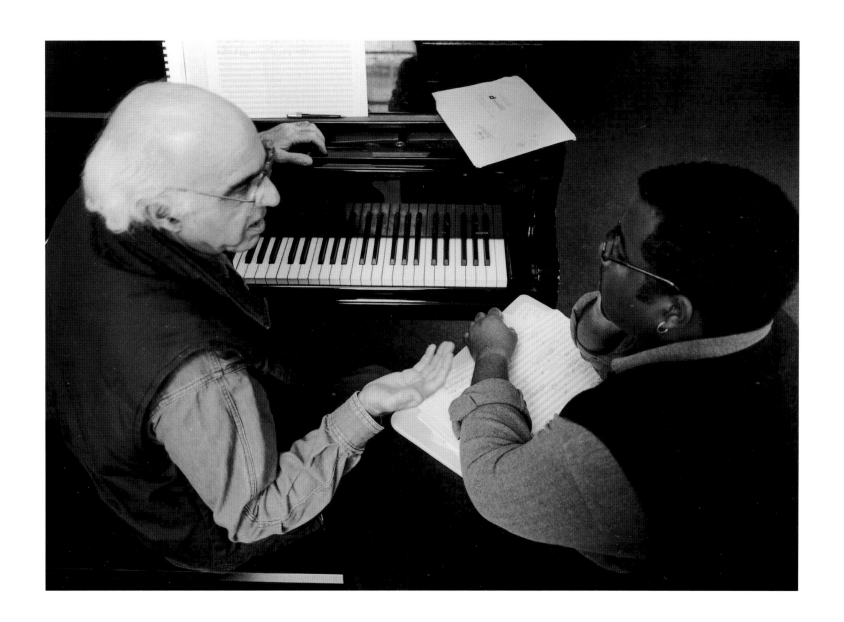

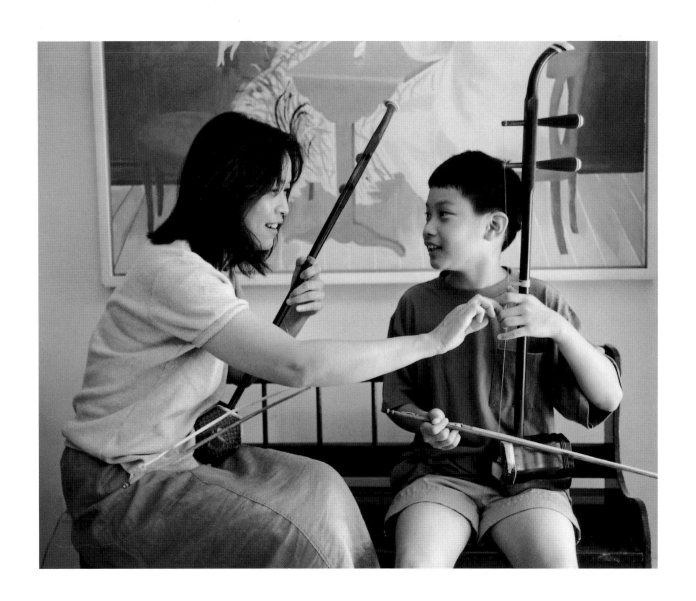

"Always listen to the sound to see if you like it. Enjoy. You don't have to finish something, but don't forget to enjoy the music!"

<div align="right">BETTY XIANG</div>

Betty Xiang, the erhu virtuoso, learned from her father, Zuying Xiang, a renowned Erhu master and professor at Shanghai Conservatory of Music. She made her debut at age 17 in Canton and Shanghai. She has performed with major orchestras in France, Singapore, Taiwan, Malaysia, and Japan. She makes the instrument sing with emotion, and has won many awards. She has also been a music critic and made numerous recordings, some with her husband, Yang Wei, a pipa virtuoso called the "Most outstanding pipa performer of modern time."

With the Cultural Revolution, their lives changed drastically. Her father's orchestra was disbanded, and he was relegated to a factory, and they feared neighbors would inform on them if they played their instruments. But he gave her clandestine lessons, and she became one of his best students. Yang Wei won the most prestigious competition in 1989, though his triumph was overshadowed by the Tiananmen massacre. Although the two played hundreds of concerts a year, the atmosphere was stifling.

Encouraged by the success of composers Bright Sheng and Tan Dun in the West, they decided to start a new life and went to the U.S. with their son, Eric. They have become increasingly prominent on Chicago's world-music scene.

Both were involved with Yo-Yo Ma's Silk Road Project, in which Ma explored the rich cultural and music traditions of the Silk Road, tracing the threads that join the East and the West. Xiang and Yang performed recently with Yo-Yo Ma in Carnegie Hall in a project reaching out to students and teachers in New York.

Both teach their instruments, managing to transcend borders, as well as playing classical Western and Chinese traditional music on the erhu and pipa.

"Wow! Bam! That's where you come in. But ... let the smoke clear before you begin. And then play with all your heart! And don't be afraid to share it with us."

<div align="right">OWEN YOUNG</div>

Owen Young began playing cello at 6. A cum laude graduate of Yale, he played with the Atlanta Symphony and the Pittsburgh Symphony before joining the Boston Symphony Orchestra in 1991. A frequent collaborator in chamber music concerts, he has appeared in the Tanglewood, Aspen, Banff, Davos, Sunflower, Gateway, Brevard, and St. Barth festivals. As a concert soloist he has appeared with numerous orchestras, including the Pittsburgh Symphony, Boston Pops, Salisbury Symphony, Racine Symphony, and the San Antonio and Pro Arte Chamber Orchestras.

He is a founding member of the innovative chamber ensemble Innuendo, and he gives recitals in the U.S. and abroad. He has performed frequently with singer/songwriter James Taylor. Mr. Young has been on the faculties of the Boston Conservatory, New England Conservatory Extension Division, and the Longy School of Music.

He is active in Project Step (String Training and Education Program for Students of Color) and the BSO's Boston Music Education Collaborative. He served for five years as Harvard-appointed resident tutor and director of concerts in Dunster House at Harvard University, and he was a Fellow at the Tanglewood Music Center.

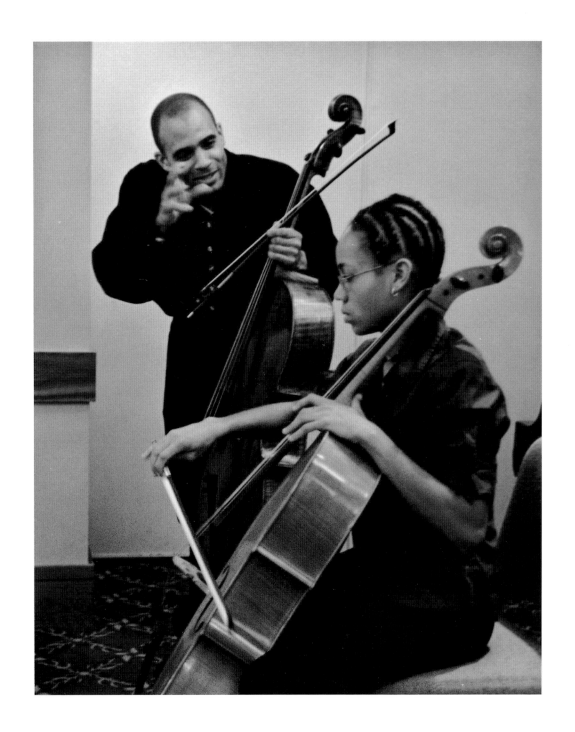

137

"Give it everything you have, as if it's the last thing you'll ever play!"

<div align="right">

BENJAMIN ZANDER

</div>

Benjamin Zander has been the flamboyant conductor of The Boston Philharmonic since its formation a quarter century ago, and with the orchestra has produced acclaimed recordings. His audiences reward him with adoration. Born in England, he began to compose at age 9. He studied with Benjamin Britten and Imogen Holst, daughter of Gustav Holst. At 15 he studied cello with Gasper Cassado and traveled through Europe performing as a chamber musician.

For the past thirty-one years he has been on the faculty of the New England Conservatory of Music, teaching graduate courses in interpretation and chamber music, and he conducts the Youth Philharmonic Orchestra. He has led the teens on many international tours. A documentary of one tour, *A New World of Music*, has won several prizes. "I've conducted orchestras all over the world, and there is nothing more exciting than this one," he says. He is also Artistic Director of the music program at the Walnut Hill School, which trains accomplished young performers. He has been guest conductor with orchestras throughout the U.S. and in England, Russia, Germany, Korea, Israel, Italy, and Japan.

Besides being a peripatetic teacher of gifted music students, he is using music now as a metaphor and has become a motivational speaker to major organizations, revving up executives from Textron to British Telecom. These talks are gathered in a book, *The Art of Possibility*, co-authored with Rosamund Stone Zander, his ex-wife and partner. One critic says Benjamin Zander plays teacher and preacher.

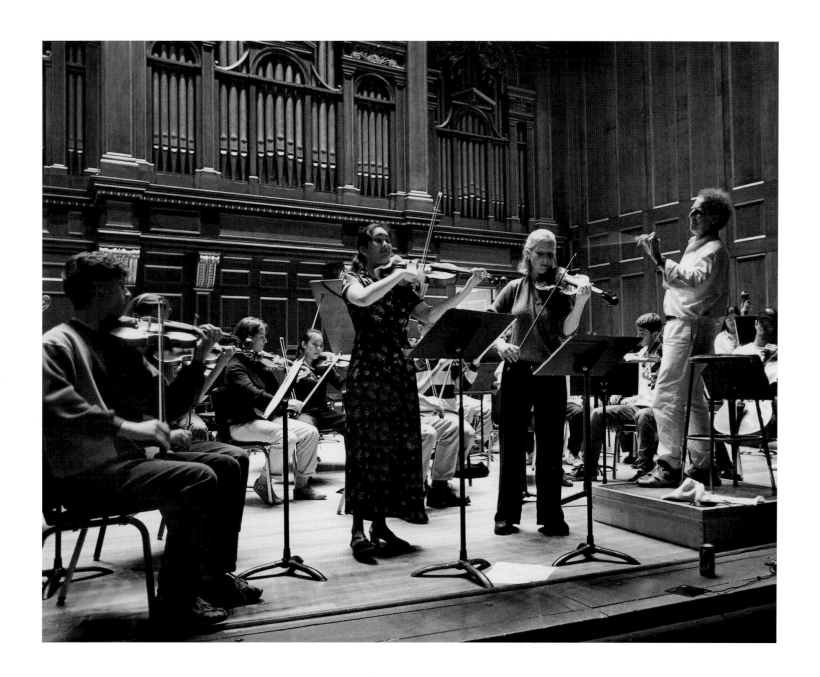

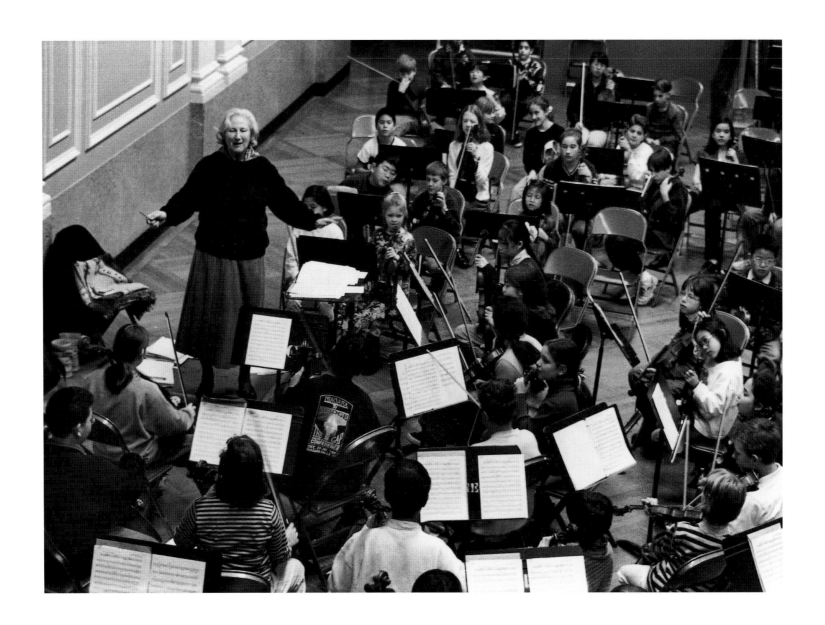

"Chaps – your posture is very soggy – lift your violins higher, straighten your backs, and look more like snobby people than cooked spaghetti."

AIDEEN ZEITLIN

Violinist Aideen Zeitlin is an Associate of the Royal College of Music in London. She studied with Albert Sammons, Erich Gruenberg, and Emmanuel Hurwitz. She also performed in Great Britain, Ireland, and on the continent with many orchestras, including the Academy of St. Martin-in-the-Fields, the London Mozart Players, Bach Tilford Festival, Festival and Rambert Ballets, and with opera companies, and with the D'Oyly Carte.

She moved to Boston in 1965 and performed in the Boston and New England areas.

She was on the faculty of the Music School at Rivers, and recently retired from the faculty of All Newton Music School, and the New England Conservatory of Music, where she was teaching violin and conducting two string training orchestras for the young in the Preparatory Division, where this photograph was made.

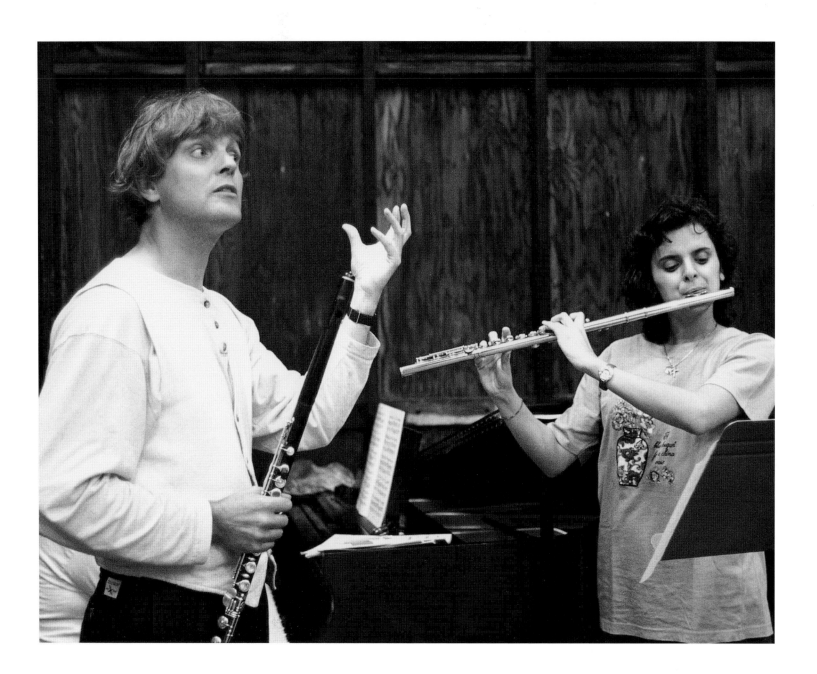

Jacques Zoon was born in Holland, one of ten children. He began playing in orchestras at an early age in Holland and with the European Community Youth Orchestra, under such renowned conductors as Abbado and Bernstein.

He has been solo flautist in the Amsterdam and Hague Philharmonic Orchestras, was appointed first flautist of the Royal Concertgebouw Orchestra in 1988 and regularly appears as soloist with the Chamber Orchestra of Europe and many orchestras throughout the world.

In 1997 he was appointed principal flute of the Boston Symphony Orchestra. In Boston, where he could be seen streaking through the streets on his reclining bicycle, he had become a busy citizen. He was a soloist with local groups and played in benefit concerts with his wife, Iseut Chuat, the cellist. Players felt they gained from every concert he participated in.

Currently, he is in Berlin playing solo and chamber music and making many recordings. He has a deep affinity with modern music, and his most visible "signature" is his wooden flute, which he feels makes a nice blend with the other instruments. His hobby is making flutes, and he has published his findings on making technical improvements to the instrument.

Zoon gives master classes, and he has been Professor of Flute at the Rotterdam Conservatory, Indiana University, Boston University, the New England Conservatory of Music, and the Tanglewood Music Center.

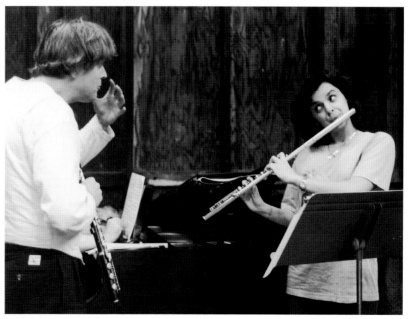

"As soon as you hear you are not in tune, never give up. If you maintain the same speed of air you will play more in tune. You cannot give up your struggle against the nature of the instrument."

JACQUES ZOON

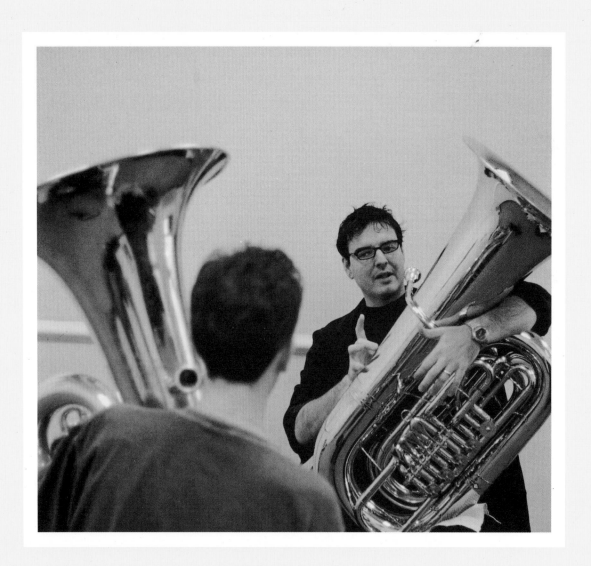